# slide show

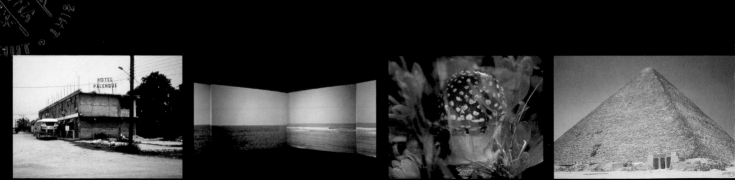

# Darsie Alexander

WITH ESSAYS BY *Charles Harrison and Robert Storr*

CATALOGUE ENTRIES BY *Darsie Alexander*

*Rhea Anastas*

*Thom Collins*

*David Little*

*Molly Warnock*

THE BALTIMORE MUSEUM OF ART | THE PENNSYLVANIA STATE UNIVERSITY PRESS

slide show

This volume has been published in conjunction with the exhibition *SlideShow,* organized by The Baltimore Museum of Art, Baltimore, Maryland, and held at:

The Baltimore Museum of Art
27 February–15 May 2005

Contemporary Arts Center, Cincinnati
2 July–11 September 2005

The Brooklyn Museum of Art
7 October 2005–8 January 2006

This exhibition is generously sponsored by T. Rowe Price.

Additional support is provided by The Andy Warhol Foundation for the Visual Arts and Suzanne F. Cohen. The catalogue is generously supported by Agnes Gund and Daniel Shapiro.

Printed in China by
Everbest Printing Co.
through Four Colour Imports,
Louisville, KY

Published by
The Pennsylvania State University Press,
University Park, PA 16802-1003

Designed by Lisa C. Tremaine

The Pennsylvania State University Press is a member of the Association of American University Presses.

*Library of Congress Cataloguing-in-Publication Data*

Alexander, Darsie.
 SlideShow / Darsie Alexander ; essays by Darsie Alexander, Charles Harrison, and Robert Storr ; catalogue entries by Darsie Alexander ... [et al.].
  p.   cm.

Issued in connection with an exhibition February 27–May 15, 2005, Baltimore Museum of Art, and at other museums at later dates.

Includes bibliographical references and index.
ISBN 0-271-02541-7 (pbk. : alk. paper)
  1. Projection art—Exhibitions.
  I. Harrison, Charles, 1942– .
  II. Storr, Robert, 1949– .
  III. Baltimore Museum of Art.
  IV. Title.

N6494.P74A38 2005
779'.074'7526—dc22         2004023032

# contents

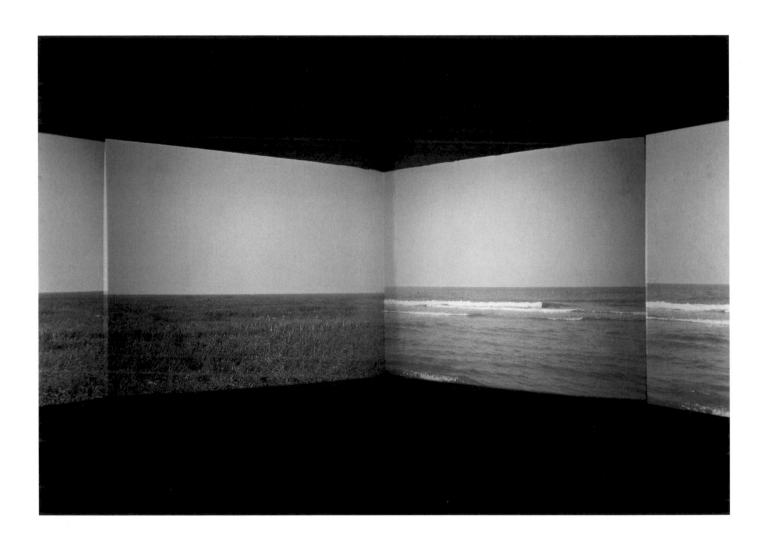

# foreword

Contemporary artists constantly find new ways to change how we think about technology, turning even the most utilitarian machines into vehicles for creative innovation. The familiar apparatus of the slide machine has inspired some of the most experimental work of the past forty years, attracting artists from a variety of backgrounds with its mechanical simplicity and high visual impact. Using slides small enough to fit in the palm of a hand, artists have produced magnificent images, projected with an unsurpassed clarity and intense color on a scale that exceeds even the most ambitious paintings of the time. These works test the limits and possibilities of how we see: not only what images will be shown, but also for how long and in what order. They turn walls into giant screens for an array of subjects—vistas of the sea, strange mushrooms blending into one another, a father and daughter spinning in an endless circle. Sometimes they provide narration; at other times, the sound of a clicking carousel is the only acoustic backdrop.

*SlideShow* records the history of this ephemeral medium and explores the reasons why artists pursued slide work as a creative outlet. It surveys nearly forty years of tremendous innovation—from the 1960s, when artists first realized the potential for slides as art, to 2002, just two years before Kodak took its slide projectors off the assembly line.

This exhibition is thus remarkably timely. Slides are still familiar to many of us, whether from home viewings of vacation snapshots and other family occasions, classroom experiences in art history, or research presentations at medical or scientific conferences. But slides are rapidly becoming less familiar: they have been preempted by the ease and accessibility of digital photography. By understanding the operative characteristics of slide projection, we may be better prepared to consider how differently we receive data in today's complex world of computer imaging. Indeed, we are on the verge of thinking nostalgically about a once cutting-edge technology. Though slide projection will soon be lost from the realm of the everyday, the edgy artwork it inspired captures and conveys its essence.

*SlideShow* also reflects the BMA's long-standing commitment to presenting and interpreting the contemporary art in its collection and through exhibitions, educational programs, and scholarly publications that chart new territory. Since the nineteenth century, Baltimoreans have collected contemporary art and enriched the BMA's collection with generous gifts, including the most comprehensive holdings, worldwide, of the work of Henri Matisse. Today the Museum's West Wing for Contemporary Art, which opened in 1994, houses contemporary work from 1945 to the present.

There are strong connections between *SlideShow* and the Museum's contemporary holdings, which include a slide piece by Robert Barry as well as Conceptual and Minimalist art that provide a context for works in this medium. The BMA's photography collection, too, contains many examples of color photography that anticipate the look and serial nature of the slides in this exhibition. The emphasis on new media signals a new direction for the Museum, which now features a growing collection of this exciting work in its contemporary wing.

We are grateful to Darsie Alexander, BMA Curator of Prints, Drawings, and Photographs, for conceiving and developing the imaginative premise of *SlideShow* as well as for her leadership in bringing this project so effectively from idea to reality. As always, it takes a team of museum professionals for the exhibition to appear in its final state, vibrant and flawless. Many other members of the BMA's staff played critical roles in raising the necessary funds; securing loans; restoring and duplicating slides; coordinating educational programs, marketing, and public relations; and, of course, producing this book and installing an extremely complicated show requiring multiple projectors, sound systems, screens, lenses, and amplifiers as well as works of art.

We would especially like to thank the artists, lenders, and donors whose generosity made this show possible. While we are enjoying each of the nineteen installations featured in *SlideShow,* they are away from the artists, collectors, and institutions with whom they regularly reside. As for the bold supporters attracted to this innovative project: BMA Board Chair Suzanne F. Cohen insured the quality of this project by supporting its research and development. T. Rowe Price Associates and the T. Rowe Price Charitable Foundation took the lead in sponsoring this exhibition, a sign of their high level of commitment to cultural innovation in Baltimore. A generous grant from The Andy Warhol Foundation for the Visual Arts enabled the BMA to take the exhibition further in scope and

execution, demonstrating once again its belief that a good project deserves to be done well. Agnes Gund and Daniel Shapiro have graciously supported this publication.

We thank our colleagues Linda Shearer, Director of the Contemporary Arts Center, Cincinnati, and Arnold Lehman, Director of the Brooklyn Museum of Art, for extending the reach of the project by presenting this important work to their communities.

And now for the first slide . . .

Doreen Bolger
*Director*
The Baltimore Museum of Art

# lenders to the exhibition

The Baltimore Museum of Art
Lothar Baumgarten, New York
James Coleman, Dublin
Jan Dibbets, Amsterdam
Ceal Floyer, Berlin
Barbara Gladstone Gallery, New York
Marian Goodman Gallery, New York
Dan Graham, New York
Solomon R. Guggenheim Museum, New York
Hayward Gallery, London
Casey Kaplan Gallery, New York
Pamela and Richard Kramlich, San Francisco
Louise Lawler, New York
Galerie Lelong, New York
Helen Levitt, New York
Lisson Gallery, London
James Melchert, Oakland, California
Estate of Ana Mendieta, New York
Metro Pictures, New York
Jonathan Monk, Berlin
The Museum of Modern Art, New York
Dennis Oppenheim, New York
Philadelphia Museum of Art
Plaster Foundation, New York
Fundació Antoni Tàpies, Barcelona
Whitney Museum of American Art, New York

*Louise Lawler, projection for*
*Individual and Collaborative*
*Works by Nine Artists, 616*
*South Broadway, Los Angeles,*
*California, 1979*

leadership and commitment to keeping the cultural life of Baltimore thriving. The Andy Warhol Foundation for the Visual Arts continued to acknowledge the importance of experimental art forms with a generous grant. BMA Board Chair Suzanne F. Cohen displayed her customary enthusiasm for contemporary art with a generous contribution at the beginning of this project. Agnes Gund and Daniel Shapiro graciously donated funds to the production of the catalogue, ensuring the longevity of *SlideShow* and the art it documents.

Many individuals from the museum and technology world offered their expertise at essential points in the evolution of *SlideShow*. Todd Gustavson, Technology Curator at the George Eastman House, supplied and proofed much of the information on slide projectors, revealing his vast knowledge of this subject. Susan Kismaric, Curator, Department of Photography at The Museum of Modern Art, New York, graciously extended her thoughts on matters photographic and logistical. Helen Molesworth, Chief Curator of Exhibitions at the Wexner Center for the Arts, aided in the early development of this project, providing many important suggestions for possible directions and approaches. Tom Beck, Chief Curator, Albin O. Kuhn Library and Gallery, University of Maryland, Baltimore County, found wonderful examples of old slide projectors and made them available whenever we needed them. David Frankel edited the main essay with his usual precision and insight. Alan and Carol Edelman have inspired this curator with their passionate interest in contemporary photography and its many permutations. Molly Warnock, an art history graduate student at The Johns Hopkins University and a contributor to this catalogue, undertook critical research tasks at the beginning of this project that remained useful to the very end. Gloria Hood's presence and warmth filled in for me many times. And Andrew Graybill is a true friend.

Coordinating loans, fielding endless queries, and managing correspondence made *SlideShow* a truly participatory project for countless administrators and museum curators. Special thanks are due to Leslie Nolan, Marian Goodman Gallery, for handling all of the above for key artists in the exhibition—and always with the utmost professionalism and care. It was a pleasure to work with Jeffrey Peabody and Victoria Cuthbert, Matthew Marks Gallery. Invaluable assistance also came from Chana Budgazad, Casey Kaplan Gallery; Ivy Crewdson, Barbara Gladstone Gallery; Jed Dietz, Maryland Film Festival; Christopher Eamon, Kramlich Collection and New Art Trust; Klemens Gasser and Tanja Grunert; Elyse Goldberg, James Cohan Gallery; Colin Griffiths, James Coleman Studio; Marvin Heiferman; Tom Heman, Metro Pictures; J. Hoberman, Plaster Founda-

tion; Marvin Hoshino; Chrissie Iles and Henriette Huldisch, Whitney Museum of American Art; Bruce Jenkins, School of the Art Institute of Chicago; John Marchant, Nan Goldin Studio; Jon Mason, PaceWildenstein Gallery; Amy Plumb, Dennis Oppenheim Studio; Lisa Rosendahl, Lisson Gallery; Mary Sabbatino, Galerie Lelong; Nancy Spector and Ted Mann, Solomon R. Guggenheim Museum; Michael Taylor and Melissa Kerr, Philadelphia Museum of Art; and Olga Viso, Hirshhorn Museum and Sculpture Garden.

This exhibition rests on the contributions of a small number of contemporary artists. In the two years spent preparing *SlideShow,* these individuals have made themselves available at virtually any time, providing vital information on all aspects of their work. The contributors to this catalogue, including Rhea Anastas, Thom Collins, Charles Harrison, David Little, Robert Storr, and Molly Warnock, closely examined the works in *SlideShow,* often traveling long distances to see the projections in person. I am grateful for their time and insights. As their labor confirms, artwork lives on not only in museums but also in books. Art History and Humanities Editor Gloria Kury at Penn State Press pulled this volume together, aided by the able staff at the Press, including Laura Reed-Morrisson and Jennifer Norton, and the talented designer Lisa Tremaine. Their creative approach and enthusiastic embrace of this project were felt at all stages of collaboration.

The tour of this exhibition reflects the hard work and adventuresome spirit of our colleagues at the Contemporary Arts Center, Cincinnati, and the Brooklyn Museum of Art. Thom Collins, now at the Contemporary Museum in Baltimore, pursued *SlideShow* for Cincinnati with great foresight and enthusiasm, and Matthew Distel creatively executed its installation. Marc Mayer, now Director of the Musée d'art contemporain de Montréal, and Charlotta Kotik made *SlideShow* a reality for New York audiences. The directors of both museums—Linda Shearer at the Contemporary Arts Center, Cincinnati, and Arnold Lehman at the Brooklyn Museum of Art—deserve particular acknowledgment for their support and vision.

Special thanks are due to my husband, David Little, who witnessed the evolution of this project from start to finish and the many weekends lost to its creation in between. His intelligence and intuition informed many critical decisions. My parents, daughters, and sisters have brought extraordinary pleasure and support along the way, for which I am truly grateful. My work on this project has been inspired by the memory of my sister Janet Alexander.

Darsie Alexander

# introduction

What qualifies a slide as art? *SlideShow* attempts to respond to this basic question by first acknowledging that slide projection has been many other things: a means of family entertainment, a way to teach art history, a vehicle for political agitation. Of course, people have always used slides creatively, and many a talented projectionist achieved the lauded status of *savoyard* during the eighteenth century for producing elaborate shows and spectacular effects using glass slides. Even a masterfully executed display of vacation snapshots may be artful. But at what point does skill give way to what we consciously define as art? When did slide projection move from the living room to the art gallery?

To address these issues is to evaluate the terms used to classify art, which may either incorporate or rule out a "popular" medium like slide projection, with its multilayered ties to commerce. Slides have, for much of their history, occupied a place in the marketing and entertainment industries—highly visible outlets, to be sure, but distinct from the traditional realms of fine art. But when the hierarchies of art came under attack in the 1960s, these high/low divisions dissipated, making room for new formats and ideas previously excluded from artistic practice. Artists found this both a great relief and a challenge. Many welcomed the opportunity to leave painting and sculpture behind, but what options stood in their place? Some drew from the familiar stuff of their lives, incorporating found objects, reproductions, and fugitive materials into their artworks. Others turned to readily available technologies for inspiration. Slide projection was one such outlet, a standard tool of the art trade that seemed to offer tremendous creative potential, especially for those looking to animate (and automate) their images. Indeed, slide projection bridged aspects of still photography and film in a distinct and meaningful way.

An extremely heterogeneous medium, slides could be adapted to a wide range of applications at a time when artists sought unusual visual combinations and attributes in their works. A painting requires a degree of finality, but a slide

Dan Graham, *Row of Houses, Jersey City, NJ,* still from *Homes for America,* 1966–67

projection can be reinvented each time it is shown, with new and different images switching in and out according to specific needs. Magnification, speed of delivery, and sequence become variables of the medium; artists can manipulate and tweak them at any stage of the process. This flexibility generated widespread experimentation with the process itself, resulting in works that could just as easily reside in a live theater as an art gallery—a blurring of lines that artists welcomed.

The title of this exhibition, *SlideShow,* recognizes the viewer's experience of watching slides as well as the artist's experience of formulating and ordering them. Though a slide itself is an image, a slide show is a phenomenon, an event that occurs at a specific time and for a designated purpose. Anyone old enough to remember slides may find it difficult to think of the medium without immediately conjuring up specific moments spent observing bright pictures flash on a screen, be it in a classroom or a hotel lobby. These are the sites of slides, the places where they are made physical by machine projection. For artists, showing slides involves a process of envisioning how they will look as projections inside architecture and, in some cases, surrounded by sound. No wonder, then, that the earliest work in slide projection focused on the particulars of mediation. How does an image change depending on where it is sequenced in a larger progression? In what ways do single images contribute to the overall effect of multiple ones? These issues affected both how artists conceived their works and what demands they placed on audience reception. The fact that slide projectors are optical devices that inform (and sometimes complicate) perception provides an underlying theme for many of the works in this exhibition.

*SlideShow* includes nineteen installations at various levels of scale and complexity. Some, like Nan Goldin's *Ballad of Sexual Dependency,* a personal story of sorts, are presented in closed environments. Others, like Jan Dibbets's six-carousel piece *Land/Sea,* relate directly to the architecture and thus to the surrounding environment of the spectator. Despite the range of works on view and their relative familiarity (or unfamiliarity) to general audiences, a historical structure linking them to Conceptualism, performance, and narrative art runs throughout. These categories are necessarily loose, as slide projection enables the mixing and matching of many different elements and themes. The more recent works, for example, are noticeably nostalgic in tone: they reflect on the use of slide projection as a vernacular medium as well as one with ties to Conceptualism. Exhibition visitors will observe that earlier works are largely

single-carousel projections; later pieces are comparatively more complex. As projected imagery in art received more competition from the sped-up world of commerce, opportunities for both critique and a new look emerged, resulting in a growing emphasis on scale, sound, and color saturation in the production of slide works today.

This publication documents the works and artists in the exhibition and analyzes the larger histories they represent. In the introductory essay, I outline major developments in the art of slide projection, focusing on its oscillating status as a form of photography, a distinct medium in itself, and—as one artist put it—"a cheap way to make a film." I also pay special attention to the beginnings of slide projection as a contemporary art practice, looking in particular at the question of why so many artists more or less simultaneously chose slides, expanding their applications of the medium far beyond mere illustration and documentation. Charles Harrison's essay, "Saving Pictures," examines the changing parameters of art during the 1960s and 1970s, noting the erosion of hierarchical distinctions within traditionally separate genres and the gradual loss of the "frame" that renders art autonomous, unique, and authentic. Slide projection, he proposes, represents a "detachment from the cultural status quo with intangibility and physical impermanence of imagery." Taking a different tack, Robert Storr's "Next Slide, Please . . ." concentrates on slides as the "common coin" of the art world—artifacts that historians and artists rely on to tell their stories, illustrate their points, and disseminate their material. In some ways, the leap from practical necessity to creative possibility would seem to be an obvious one for artists, but the transition also meant dealing with the very specific nature of the slide-as-medium. These essays are followed by detailed entries on the individual works in the exhibition, written by Rhea Anastas, Thom Collins, David Little, Molly Warnock, and me. Each entry offers an analysis of the piece in question and its role in the artist's overall body of work. Together, the elements of the book complement one another and even, at times, mark differences of opinion and attitude. By taking a variety of approaches, the texts open up diverse avenues of thought, yielding new insights into their common subject.

Writing on the subject of slide projection in post-1960s art occurs, with odd serendipity, at the moment that slide projectors are being rendered obsolete. Last September, a memo from Kodak went out to all interested parties announcing the official termination of the standard slide projector, an apparatus that has projected and reproduced images for generations. Now we are in the position of

posthumously examining slide projection as art, a task that requires an assessment of particular individuals as well as the historical circumstances that determined, in part, their changing applications of slide technology. We notice, for example, a growing interest in continuity and imagistic flow in later slide works replacing an earlier fixation on the still image as the structural foundation of slide projection. This shift toward steady, seamless images is now apparent elsewhere in our lives, as visual stimuli endlessly stream into our homes and work environments over cable and telephone wires. How do we—as consumers of popular culture—separate and edit this vast array of information? Where does the still image fit within these increasingly complicated networks? The termination of slide projection as such may signal the end of an era; it may also represent the culmination of a wider investigation into the transience of images and the fleeting nature of perceptual experience. Indeed, what accelerates may eventually disappear. Though the history of slide projection may be over, the analysis has just begun.

Darsie Alexander
February 2005

essays

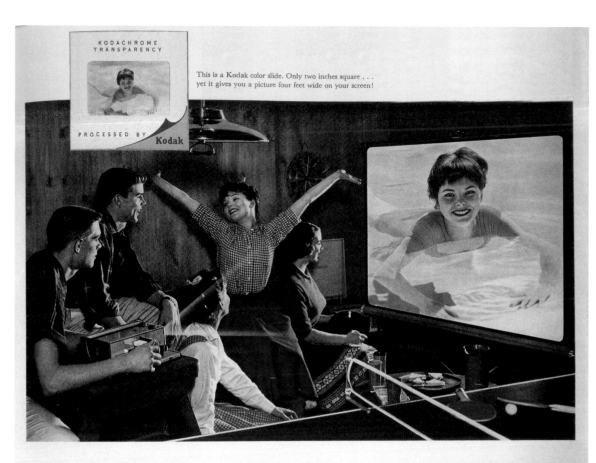

KODACHROME
TRANSPARENCY

PROCESSED BY Kodak

This is a Kodak color slide. Only two inches square . . .
yet it gives you a picture four feet wide on your screen!

# "Turn on" your vacation <u>big-as-life</u>...with Kodak color slides!

*You get pictures of family
and friends so real they all
but smile back at you!*

Now you can save your summertime fun
in the most lifelike pictures you've ever
seen. Show your fun as big as you can
spread your arms! You'll get colors so
clear, so crisp, they bring back the splash

of blue water, the warmth of golden
sunlight, the glow of a healthy tan. You
can get started now in 35mm Kodak
color slides for as little as $2.95 down.
Look how easy it is . . .

**1** *You're an expert at once* with the Kodak
Pony II Camera. Pre-set shutter, easy "zone"
focusing. Fast *f*/3.9 lens gets great color
slides and Kodacolor snapshots. Ask your
dealer about trading your old camera. $29.50

**2** *Get all the color* with world-famous Koda-
chrome Film. And ask your dealer about the
Kodak Prepaid Processing Mailer which per-
mits you to mail your film to Kodak for proc-
essing and get your slides back by mail, too.

**3** *Show your slides proudly* . . . full-screen . . .
with the Kodak 300 Projector. It's compact, so
easy to operate. With Readymatic Changer,
$64.50 or as little as $6.45 down. (Other
Kodak projector models to $149.50)

Many dealers offer terms as low as 10% down. Prices are list, include Federal Tax, and are subject to change without notice.

*See Kodak's "The Ed Sullivan Show" and "The Adventures of Ozzie and Harriet"*

**Kodak** TRADEMARK

## EASTMAN KODAK COMPANY, Rochester 4, N. Y.

9594 (1959)

*This advertisement appears in*
Life—July 20
Saturday Evening Post—August 1

# SLIDESHOW

## *Darsie Alexander*

*New babies just home from the hospital, children cavorting under the Christmas tree,*
*weddings, receptions, birthday parties. . . . These and many other happy memories live*
*on through the magic of color slides.*
> —*New Adventures in Indoor Color Slides,* 1967 Kodak instruction manual

The magic of color slides. There was a time, not long ago, when this phrase required no further explanation: such was the status of slide projection as the picture-perfect means of viewing family snapshots. For those accustomed to album pages and mantelpieces as the primary display avenues for personal snapshots, slides revolutionized the look and power of photography by making pictures bigger, brighter—and, as Kodak would have it, better. Maybe it was the scale of a slide projection, which made ordinary subjects larger than life; maybe it was the sharpness of a good slide glowing in the dark on an iridescent silver screen; perhaps the magic centered on the relationships, both visual and social, that slide projection fostered. Whatever the reasons, the magic of slides rested on visual as well as psychological forces. Who could deny the power of seeing a brilliant projection of oneself in front of a select and captive audience of family members? Slides provided something that no other photographic medium offered—a communal experience of showing and receiving large-scale pictures of private life in a color-saturated palette. Family slide shows were a coming-together for members of a discrete clan, a time to watch and reminisce in the comfort of the living room. "These and many other happy memories live on. . . ."

For a generation captivated by images pulsing across laptops and digital pictures of friends on cell phones, such claims about the magic of color slides may well seem exaggerated. It is hard to imagine a time when a person would marvel at the sight of him- or herself on the screen (indeed, how many of us today witness ourselves staring back from advertising kiosks and computer monitors while walking down the street?). Similarly, it may be difficult to comprehend the

Kodak advertisement designed to appear in *Life* and *The Saturday Evening Post,* 1959

novelty of color when it was first made widely available through slides in the 1940s and 1950s, long before quick-stop color printing became as easy as driving to the local drugstore. We now take these inventions for granted, often with little understanding of the attitudinal shifts they demanded. Accepting color, for example, came much faster to amateur photo-enthusiasts than it did to professional photographers trying to gain acceptance as artists. Those striving to promote the seriousness of their medium saw color as crass and even frivolous, an element that could potentially undermine their long-term aesthetic and journalistic goals. (Only in 1982 did a major American newspaper, *USA Today,* inaugurate its first issue with color; *The New York Times* followed suit some fifteen years later, over the protestations of many devoted readers.) And for the better part of the twentieth century, artists considered slides *merely* a reproductive means to illustrate and archive their work. Slide transparencies often served as documentation, but rarely in a creative context—at least not until the 1960s, when artists' definitions of art radically expanded to include technologies once considered too familiar, accessible, and low.

This catalogue examines the conditions under which a group of experimental artists discovered slide projection, producing work that has existed on the periphery of art history until now, the very year in which the technology that powers slides has become obsolete. Discovery does not equal invention, however, especially for a medium as old as this one. Rather, slides were a found medium, a preexisting format made for one group of consumers and later appropriated by another. Businessmen in the 1950s and 1960s depended on slides as sales tools, presenting their products to clients in the form of glowing images; housewives used slides to display family snapshots on foldout screens; teachers of math, art, and the social sciences illustrated their lessons with slides. When artists took up slides in the 1960s, then, they faced both opportunities and challenges: exploring the properties of slides was hardly the equivalent of working with a blank slate or an empty canvas, and every artist sufficiently inspired by the medium necessarily faced its particular, ingrained associations.

So who were these artists? The strongest proponents of slide projection came from Conceptual and performance art, which emerged in the 1960s and 1970s to explore the concept of time. In contrast to the firmness and solidity of a two- or three-dimensional object, the pursuit of time as a theme was, by its nature, elusive. In some cases, artists created temporary works that existed for a specified duration and often involved seemingly mundane physical activity. In others,

they used the camera to record instantaneous degrees of time in concert with the actions or interventions they wanted to document. Rejecting the idea of art as something finite, these artists sought ways to convey the process of *making* their work, one that included progressive steps as well as digressions and reversals. Slide projection was a perfect medium by which to express these interests. Specifically, it provided a way to capture time by operating as a vehicle for photographs made at split-second intervals; moreover, as a system for automating and moving still images, it registered time, breaking and accelerating the time intervals between pictures. Given these features, it comes as no surprise that slide projection was often considered a bridge between photography and film. The round slide carousel, the kind most frequently used by artists in this exhibition, contains successive slots for images, which are projected *in time* and in sequence, like a film. But by the same token, the different frames capture a past moment that was taken *out of time,* like a photograph.

That such a simple device as a slide projector could produce complex themes was part of its appeal. The medium was highly adaptable to different interests and needs. Though performance and Conceptual artists shared some of the same preoccupations, they found in slide projection many variable elements through which to communicate: an automated device for slowing down or speeding up sequences, an ordering tray for images that allowed for easy editing, and a straightforward operational system that required virtually no expertise. Not only could slide projection function as a form of installation art (with images covering the walls with light) and freeze continuous action like a movie still, but it also offered many options for the expression of ideas in the form of large-scale, fleeting images. Slide projection, then, embodied specific physical traits and provided a format for reflexively exploring these traits as concepts. Projected slides presented artists, especially those engaged in more than one medium or approach, with much-sought-after versatility at a time of tremendous artistic experimentation and heterogeneity. The modest slide machine, it turned out, was a wide platform for investigating the look and the boundaries of contemporary art.

EARLY HISTORY

The unique experience of viewing color slides was a phenomenon that both consumers and producers of slide imagery recognized almost as soon as the medium hit the market in the late 1930s. In 1935, Leopold Mannes and Leo

1. Naomi Rosenblum, *A World History of Photography* (New York: Abbeville Press, 1984), 610–11.
2. Douglas Collins, *The Story of Kodak* (New York: Harry N. Abrams, 1990), 214.

Godowsky, trying to find a way to enhance the accuracy and accessibility of color photography, invented the process that would be patented as Kodachrome.[1] A dramatic improvement over older techniques that relied on complex optical systems, Kodachrome produced a perfectly registered color spectrum that resulted in clear and luminous transparencies. At first the film came to consumers in the form of strips that could be run through a movie projector or cut down into individual frames or slides and fed manually into a slide projector. Kodak realized that the ease and compactness of slides would be their greatest commercial asset, and by 1939 the company had begun to manufacture two-by-two-inch slide mounts and a simple projection unit to sell to a growing market (one that would peak after World War II).[2] It was apparent that slides were the next novelty for photography enthusiasts—small enough to hold in the palm of the hand but spectacular in scale, sharpness, and color intensity when magnified by the projector. Unlike movie film, which delivered a blur of constant motion, color slides froze moments in time with an arresting brilliance. Gone was the graininess of black and white; color slides determined a new look for images on the big screen of the home living room.

Slide machines were designed to be portable and uncomplicated, and each new evolutionary advance brought greater accessibility. Though several developments and diversifications improved upon the 1930s and 1940s projectors, most stayed within the basic hand-feed configuration, which required an operator to load slides manually into a horizontal or vertical carrier. Some projectors came with so-called stack loaders, in which a spring pushed the slides, one by one, into the gate of the projector. These projectors provided dazzling images for the screen. It was, however, a revolutionary step when automated projectors capable of holding large groups of slides became available in the 1960s. The round slide carousels allowed for the successive display of images at a steady pace, providing backward and forward motion with unprecedented ease. The remote feature also meant that the speaker and slide operator could be one and the same, enabling greater synchronicity between images and words. Teachers and business professionals alike found new freedom in the quickness of automated slides and in their own ability to control the order and speed of images from afar.

One of the most popular sites for slides—especially for artists—was the classroom. The trend of using slides in school dated to the late nineteenth century, when art historians exploited a new technology for transcribing photographic images onto glass. In 1850, William and Frederick Langenheim, two brothers

from Philadelphia, took the glass-plate negative process devised by the French inventor Nicéphore Niépce and used it as the basis for their invention of the positive transparency. The capture of photographic information in slide form meant that pictures could be presented to audiences with limited access to the originals, offering intimate views of distant subjects for analysis. For those accustomed to drawn or engraved illustrations, slide projection had the credibility of scientific objectivity that came with photography; to show slides in the classroom signaled pedagogical sophistication and seriousness. Professors at both Harvard and Yale universities, for example, began using slides in the 1880s, at which time the institutions also inaugurated their graduate art history departments.[3] The medium also supported new approaches to art. No less a scholar than Heinrich Wölfflin—one of the first to employ twin projectors in the classroom—initiated a pedagogy that linked the compare-and-contrast model of slides to his own binary interpretation of art's categories (i.e., linear versus painterly). By the 1920s in Germany and elsewhere, schools had established picture departments, or slide libraries, that tracked the flow of images for instructional purposes.[4] These departments formed a clearinghouse for slides, a system of order and classification that students as well as historians could master. Over time, a lively trade sprouted up to service the large demand for slide pictures, forming a new industry for their production as well as distribution.

The notion that slides, in the hands of a great teacher or orator, could be educational *and* entertaining is nearly as old as the medium itself. The phenomenon of the public slide show dates back to the eighteenth century, when skilled professionals created extravagant magic lantern displays, thrilling audiences with their mysterious and elusive projections. The invention of the magic lantern is attributed to the Dutch astronomer Christiaan van Huygens, who in 1656 devised an instrument to project painted slides using a candle, lantern, and concave mirror.[5] Subsequent advances by scientists as well as laymen enhanced the sophistication of slides and projection equipment. One instrumental figure was Etienne Gaspard Robertson, a nineteenth-century master of special effects, who produced horror shows featuring ghosts, fainting maidens, skeletons, resurrections, and other phantasmagoria, operating his wheeled projector from behind a translucent screen. Drawing on the inventions of such renowned figures as eighteenth-century scenic designer and painter Philippe-Jacques de Loutherbourg, these traveling showmen—or *savoyards,* as they were known—produced drama out of doors, under tents, and in theaters across the Continent. By the late

3. Frederick N. Bohrer, "Photographic Perspectives: Photography and the Institutional Formation of Art History," in *Art History and Its Institutions: Foundation of a Discipline,* ed. Elizabeth Mansfield (London: Routledge, 2002), 250.

4. Sigrid Schulze, "Lichtbild und Schule: Zur Verwendung der Diaprojektion im Schulunterricht in den zwanziger Jahren," in *Dia/Slide/Transparency,* exhibition catalogue (Berlin: Neuen Gesellschaft für Bildende Kunst, 2000), 168.

5. The development of slides and other viewing mechanisms is outlined in Barbara Maria Stafford and Frances Terpak, *Devices of Wonder: From the World in a Box to Images on a Screen* (Los Angeles: Getty Research Institute, 2001).

Advertisement for a joint
lantern and motion picture
show, ca. 1900

nineteenth century, magic lantern shows had reached the pinnacle of their popularity, with such organizations as the Royal Polytechnic Institution in London featuring elaborate spectacles combining multiple projectors, musical accompaniment, and complex image sequencing. Indeed, attending magic lantern shows was akin to going to the movies today.

When did slide projection become a medium for art? Surely the great inventors of magic lantern shows must have considered their efforts artistic on some level, as the shows required not only skill but also creativity and planning. Yet for much of this early history, slide projection was seen primarily as a distraction from the routines of everyday life, an escape to the fantasy of the dark chamber. This is not to suggest that the aesthetic possibilities of transparent images were lost on artists. The eighteenth-century English painter Thomas Gainsborough, for example, explored projection with his famous "exhibition box,"[6] a device for viewing slides by candlelight. The idea that Gainsborough considered his slides on the same level as his paintings seems improbable, though. However beautiful the images, which glowed like stained glass, painting still occupied the highest rung on the ladder of the fine arts up through and including much of the twentieth century. Slides, on the other hand, remained a people's medium, appealing to a general rather than an elite audience. Especially after the invention of photography, which tied the slide image to an ever-more-literal reality, slide projection seemed destined to remain a fleeting amusement and, occasionally, to provide effective social commentary. The New York police reporter Jacob Riis, for example, barnstormed America with his lantern images of urban poverty in the 1880s, hoping to rouse sympathy and eventually relief for the city's underclass.[7] Riis's poignant images sparked reform, but his mission was shaped more by humanitarian concern than aesthetics. Along with printed magazines and newspapers, slides offered a highly effective means of disseminat-

6. Jonathan Mayne, "Thomas Gainsborough's Exhibition Box," *Victoria and Albert Museum Bulletin* 1, no. 3 (1965): 17–24.

7. Jacob Riis is best known for his book *How the Other Half Lives,* published in 1890. Though his photographs of urban poverty were widely circulated in paper formats, many of them originated as lantern slides that he used to present the work publicly "as no mere description could." Riis—and, later, Lewis Hine—saw the capacity of slide technology to disseminate information on poverty and in so doing to facilitate social change. See Beaumont Newhall, *The History of Photography: From 1839 to the Present Day* (New York: The Museum of Modern Art, 1988), 133.

8. Alfred Stieglitz, "Some Remarks on Lantern Slides," *Camera Notes* (October 1897); reprinted as *Some Remarks on Lantern Slides* (New York: DaCapo Press, 1978).

9. Ibid, 32.

ing information to large groups of people—and once gathered in a room, they became a captive audience.

The task of advancing the artistic dimension of slide projection was reserved for Alfred Stieglitz, the photographer and outspoken proponent of modern art in the early twentieth century. Stieglitz fought aggressively to introduce experimental formats and styles—especially those attached to photography—to the New York art scene. In addition to exhibiting photography and founding a prominent gallery, Stieglitz advocated his cause through the sumptuously illustrated magazines *Camera Notes* (1897–1903) and, later, *Camera Work* (1903–17). In one of his essays, "Some Remarks on Lantern Slides," Stieglitz designated 1897 the "Lantern Slide Year," highlighting the medium's tremendous popularity in camera clubs across the country.[8] Keenly aware of the special features of slide projection, he concentrated on both the production and display of slides. Quality, he argued, cannot be limited to the glass image itself ("Fog is always to be avoided in slides") but necessarily involves controlling the atmosphere in which the pictures appear. He acknowledged that "leading pictorial photographers of Great Britain and the Continent look down upon slide making as outside the 'art limits,'"[9] but Stieglitz went on to defend its aesthetic potential, offering practical guidance for photographers of various levels of experience. Though indeed slides were generated by a machine—a true detriment, in the minds of many, to its sought-after status as an art form—Stieglitz emphasized that creative success depended on decidedly human faculties, the eye and hand in particular. Superior vision and execution could, under the right circumstances, result in the realization of slides as a form of artistic expression.

Despite these valiant early efforts, however, slides did not catch on as a medium for artists until the second half of the twentieth century. The reasons were manifold, but prominent among them was the fact of painting's dominant position in the long-standing hierarchies of art. Still, those who grew up admiring the swift movements and bold compositions of the Abstract Expressionists at midcentury ultimately aspired to different goals, focusing on less concrete manifestations of artistic ideas. It wasn't that the art of the past was seen as inferior or insignificant; rather, its values seemed increasingly irrelevant to the new social and artistic climate of the 1960s. As widely accepted norms of style and behavior came under attack from all sectors of private and political life, the terms of art also shifted. What could (and could not) be called art no longer seemed so clear. Many were interested in the slide medium because it was free of artistic pretense and

pedigree: it was cheap, user friendly, and easy to reproduce. The associations conjured by slides—whether from home, work, or the classroom—appealed to those who rallied against the art establishment by accepting everything common it seemed to ignore or refute, from schlock television to B movies and advertising. In this way, artists strove to move "beyond the frame," beyond everything precious and static.

A desire to identify their art with all aspects of life, from the memorable to the mundane, forced artists to reconsider everyday activities with a deeper level of awareness. This applied not only to such physical endeavors as walking, lifting, or breathing—all of which became subjects for artworks in the 1960s—but

10. Dan Graham, interview by Darsie Alexander, 6 September 2002, New York. See also Rhea Anastas on Graham's *Homes for America* in this volume.

11. Museum of Modern Art records indicate that William Garnett, Helen Levitt, and Roman Vishniac participated in these slide evenings by showing color work in 1963 and 1967. The museum also featured several slide shows in its photography galleries, notably *Photographs of Parties* by Lee Friedlander (1 February–5 March 1972), *Unfamiliar Places: A Message from Bill Dane* (1 November–6 January 1974), and *Helen Levitt in Color* (16 September–20 October 1974), arguably MOMA's first color photography exhibition.

12. Smithson's earliest photographs were 35 mm color slides documenting the South Dakota Badlands. The pictures were taken on a family trip in 1952, establishing Smithson's early pattern of shooting slides while traveling. See Robert Sobieszek, "Smithson and Photography," in *Robert Smithson: Photo Works*, exhibition catalogue (Los Angeles: Los Angeles County Museum of Art; Albuquerque: University of New Mexico Press, 1993), 17 n. 24.

also to the tasks involved with simply being an artist, including taking pictures of one's work or talking about it with friends. Slides played an integral role in the basic organization and analysis of artists' work and served as a conduit for dialogue with an inner circle of peers. Enjoying dinner or a drink with friends while watching slides was a common way of socializing and exchanging ideas. Robert Smithson and Nancy Holt held salons in their New York loft, for instance, where artists would gather to discuss their latest efforts, aided by image and projector. (Dan Graham recalls showing his slide piece *Homes for America* [1966–67] there before it was publicly exhibited.)[10] Institutions such as The Museum of Modern Art featured slide evenings to promote conversation between artists and the public; a version of this forum still exists today.[11] These events gave artists the opportunity to experiment with slides as a means of engaging a wider audience for their work while learning to master the projection equipment and attendant presentation strategies. Here lay a technology at the artists' very fingertips—a format routinely used for practical purposes and now ready for redeployment as the new medium of choice.

Robert Smithson was among the first to combine the functional role of slides as documentation with a manipulation of the medium as an enigmatic form of self-expression. He is best known as a maker of earthworks—large, temporal formations sculpted in nature. Yet he was also a remarkable recorder of those sites who used his camera both to depict and to visually transform the subjects before his lens. Visits to remote locations to scout out new terrain for his work generated many opportunities to photograph with slides.[12] In 1972, Smithson presented a series of slides taken three years earlier to a group of architecture students at the University of Utah—a lecture that has since become known as *Hotel Palenque* (1969–72). Like many Smithson pieces, this one is difficult to classify, crossing the lines between travelogue, artist's talk, and performance activity. The pictures show a run-down Mexican hotel that appears to be in the process of either construction or degradation. Along with the slides, a taped recording of the artist's voice emanates from two speakers, conveying his insightful (though often tongue-in-cheek) observations. Watching the piece from a remove of thirty years produces a strange conflation of time zones, with the narrative and clicking of slides possessing an immediacy that is undercut by a sense of historical distance. (The artist died in 1973.) One considers the possibility that under different circumstances, he might have offered another reading of his own images, and that the work is very much of its time. Smithson called

attention to the fact that slides can radically change meaning according to how they are ordered and explained, but he also demonstrated that they might be an avenue to experimentation and critical thought.

A number of artists realized the possibilities of slide projection more or less simultaneously in the 1960s—often through the simple act of making documentation. No slide organization produced a manifesto, nor did any early landmark exhibition proclaim the medium's aesthetic importance. Rather, slides became (and continue to be) part of the more general rise of moving-image formats. Several factors contributed significantly to this phenomenon. Artists whose primary mode of expression came through the creation of temporal acts or impermanent objects relied on the camera as both an objective observer and a validating presence. Their works often occurred in remote locations with few bystanders and thus could only be known to the outside world through media outlets (still photography, film, and video). When the artist Robert Barry, for example, released helium into the atmosphere in a 1969 work, he brought a tank of the gas and a camera to the site. Fully aware of the invisible nature of the work, he used photography to generate a visual record that could appear in magazines and galleries. Fortunately, just as artists developed new needs for the camera as a witness, it became smaller and more accessible. In the early 1960s, Kodak began manufacturing the Instamatic, a popular still-photograph camera with easy-to-load cartridge film, autofocus, and flashcube advance. In 1967, Sony introduced the PortaPak, which made video available to an amateur market. This handheld camcorder was primitive by today's standards, but it permitted artists to record whatever they wanted—from impromptu performances to street protests—on location. These and other advances resulted in a proliferation of media-based work in the 1960s and 1970s that changed the terms of artmaking and the applications and potential for such familiar objects as slides.

A particularly relevant theme for slide projection emerged amid this growing interest in the camera: what was the status and future of the still in a new era of moving images? When the filmmaker Ken Jacobs asserted in 1965 that advanced filmmaking leads back to Eadweard Muybridge, he pointed to artists' fascination with the serialized photograph as the structural foundation of film.[13] The illusion of movement on the one hand and its total reduction to a row of discrete frames on the other became, among other achievements, Muybridge's chief legacy for a generation deeply invested in undermining the divisions among such media as photography and film. This disruption is clear in Chris Marker's now-classic

13. Ken Jacobs, quoted in Kerry Brougher, *Art and Film Since 1945: Hall of Mirrors*, exhibition catalogue (Los Angeles: The Museum of Contemporary Art; New York: The Monacelli Press, 1996), 83. The remark originally appeared in Jacobs's "The Nervous System," a project description.

Eadweard Muybridge, *Two Men Boxing* from *Animal Locomotion*, 1887, collotype

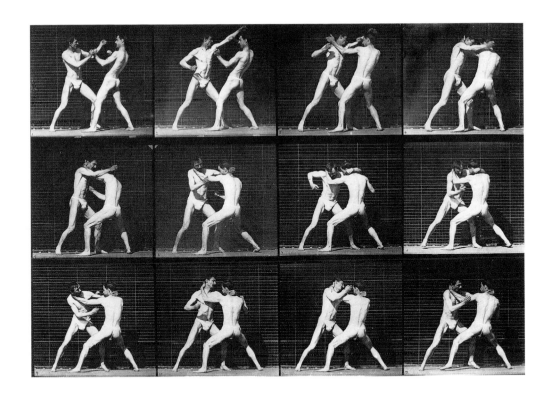

14. Cindy Sherman writes, "I remember stumbling across a bizarre futuristic film that was made up of nothing but still images except for one of the final scenes, which moved: Chris Marker's *La jetée*, which must have been on PBS when I was a teenager. I didn't know it was science fiction, it was just very weird." See Sherman, "The Making of Untitled," in *Cindy Sherman: The Complete Untitled Film Stills* (New York: The Museum of Modern Art, 2003), 4.

film, *La jetée* (1962). Composed almost entirely of a succession of still images that unfold like a flipbook, this film employs photographs as the quintessential embodiment of the flashback. Its main protagonist, trying to reconstruct an event that he can neither fully reassemble nor forget, remembers in stills arranged like fragments that never quite cohere. Marker's film is flawlessly constructed to end close to where it begins: on an airport platform. Intense emotion builds up over the course of each scene, with every still adding to the next as a memory detached from the lived moment, until the final climactic episode. Marker presents the narrative as freeze-frames filled with enigmatic moments in which the characters express longing, fear, and desire. (These images inspired subsequent works, too—notably Cindy Sherman's *Untitled Film Stills* [1977–80], in which the artist herself plays various actress types in highly charged stills seemingly extrapolated from Hollywood B movies.)[14] As a film investigating the psychological power of the still, *La jetée* captures the complex relationship between the forward drive of film and the fragmentation of photography, a tension that also informs slide projection. A slide carousel holds distinct frames

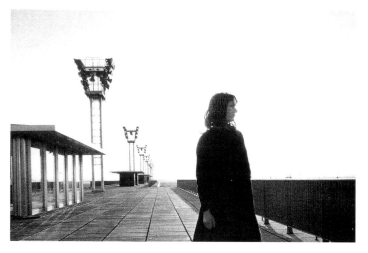 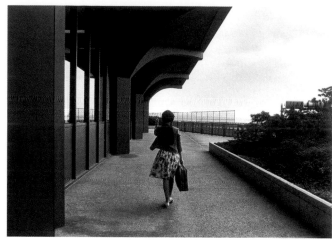

*left:* Chris Marker, still from
the film *La jetée,* 1962

*right:* Cindy Sherman, *Untitled
Film Still #59,* 1980, gelatin
silver print

that progress, one after another, on the projection screen, facilitating a step-by-step development according to ordered images. As in Marker's film, however, the images are entirely autonomous, separated by numbered slots. With each new slide comes an opportunity to build upon what came before—or to break with it to take a new direction or consider a new theme.

The contradictions embodied in slide projection as a combination of still (the image) and moving (the carousel) media inspired some of the most inventive work done during the 1960s and 1970s. Slide projection created seemingly endless possibilities for the mixing and overlaying of pictures, allowing for constant editing and revision that underscored its hybridity. Drawing upon the medium's vast social reference points, pictures from disparate sources could be compared or sequenced to promote new visual relationships. In its domestic applications, slide projection was a means of solidifying personal memory. In the business arena, it was the perfect sales tool, as it captured new products in saturated colors. In the classroom, slides functioned as reproductions, often giving artists their first exposure to the masterworks of past generations. These myriad roles constituted a history that situated slides in an array of realms—including, but not limited to, art. Slide projection represented a common "language" that the general public could understand, but it also engaged the concerns of artists seeking to explore the principles of art as a fugitive process, a projection of ideas and images.

Conceptual artists of the 1960s were among the first to consider color slides in the context of making art, deliberately circumventing conventions of the art market by employing such a simple and widely available technology. These artists generally did not identify themselves by medium or method. Most traversed practices easily, experimenting simultaneously with performance, idea art, interactive or transactional art, and earthworks. Their pieces were often impossible to see, let alone buy, supporting what most Conceptualists wanted: namely, work that produced transitory experiences rather than material objects. At least in principle, these works did not require gallery walls, eager consumers, or elaborate catalogues making claims for their significance. Art, they taught over and over again, was by no means a stable classification. An artist is at liberty to designate virtually anything as art and to assign limitless potential sites for its realization—land, street, alternative space. The only fixed quality of art insofar as Conceptual artists were concerned was that it be executed in whatever medium seemed appropriate for the purpose, regardless of hierarchy or limitation.

A widespread resistance to making commercial objects resulted in a growing preference for the immateriality of projection. Since 1920, when Naum Gabo renounced "static rhythms as the only elements of the plastic and pictorial arts,"[15] light as the mediating force of projection has occupied a crucial position in the avant-garde. The coincident rise of kinetic and of light-based art led one 1960s critic to note that "this is not simply an art which is dependent on the environment, or includes a comment on it, or can be conceived as a function of it. It is principally an art which acts on and transforms the environment."[16] The channeling of light through projectors, prisms, plastic sheets, rods, and mirrors dramatically altered the look and feel of 1960s art, bringing the technology of illumination to the forefront of visual display. Andy Warhol and Dan Flavin propelled this development early in the decade, each in a separate way. Warhol's work—the films *Sleep* (1963), *Kiss* (1963–64), and *Empire* (1964), for example—involved the prolonged contemplation of single subjects over the course of many hours. These films, with their deliberately repetitive content, served to highlight the activity of filming, which becomes all the more apparent in the absence of an overt story line. At roughly the same time, Flavin had begun to show how the glowing colors of even the simplest fluorescent light fixtures would transform space. His strategy, which employed inexpensive, industrially produced tubes,

15. George Rickey, "Origins of Kinetic Art," *Studio International* 173 (February 1967): 66.
16. Frank Popper, "The Luminous Trend in Kinetic Art," *Studio International* 173 (February 1967): 75.

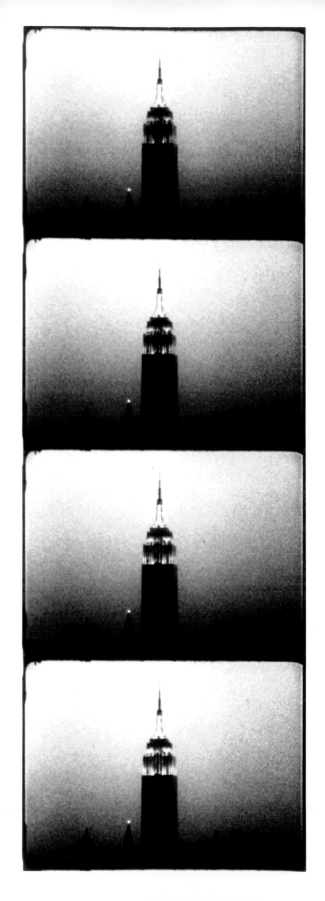

was a powerful challenge to the traditions that had defined art as a labor-intensive, lasting product. Daringly simple as it was, Flavin's work provided viewers with an experience of light's capacity to affect, subtly, atmosphere and mood. Warhol and Flavin stripped their work down to these bare elements and, by doing so, explored the ways in which light can manipulate one's experience of time (a film's extended duration) and space (a color-filled room). The issues that these two artists highlighted through their work would become critical ones for artists thinking about the resources of slide projection. How might projection alter the impact of an image and the environment in which it appears? To what extent would the viewer's perceptual self-awareness be triggered by the act of watching slides unfold in time? What qualities rendered slides distinct from other projection formats?

Dan Graham played an essential role in theorizing slide projection as a medium for artists.[17] In 1970, he began an essay on slides by considering the historical function of the viewing apparatus in shaping perceptions of movement. To see motion of any appreciable speed, he argued, first one had to break it down photographically into minute and serial frames that were then animated with the aid of an optical device. Graham explained this phenomenon with examples from the pioneering efforts of Eadweard Muybridge and Étienne-Jules Marey, who invented instruments in the late nineteenth century for, as Muybridge put it, "synthetically demonstrating movements analytically photographed from life."[18] Muybridge employed a series of cameras lined up to take one quick image after another, whereas Marey used a single high-speed, multiple-exposure apparatus to produce successive images on the same strip of film. With these accrued fragments of photographic time, Graham observed, "No moment is created: things—moments—are sufficient unto themselves. . . . We see and measure things only by related distance or in terms of ordinal placement. . . . Things don't happen; they merely replace themselves relative to the framing edge and to each other." Graham underscores the separateness of the individual elements and their flat, nearly abstract values in his *Homes for America,* a work now known to many as a magazine layout, though it origi-

Andy Warhol, stills from the film
*Empire,* 1964

Dan Flavin, *The Diagonal of May 25, 1963 (to Constantin Brancusi)*, 1963, yellow fluorescent tube

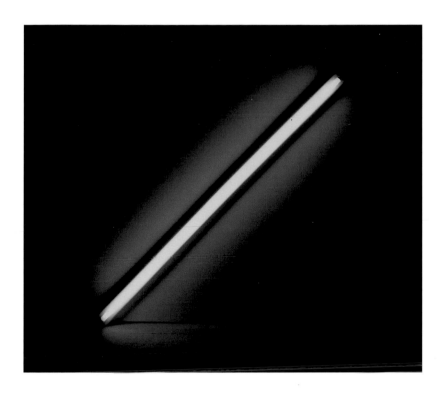

17. Dan Graham, "Photographs of Motion," in *Two Parallel Essays: Photographs of Motion/Two Related Projects for Slide Projector* (New York: Multiples, 1970).

18. Rosenblum, *World History of Photography*, 233.

19. Martin Friedman, "The Floating Picture Plane," in *Projected Images: Peter Campus, Rockne Krebs, Paul Sharits, Michael Snow, Ted Victoria, Robert Whitman*, exhibition catalogue (Minneapolis: Walker Art Center, 1974), 6. This observation is corroborated in more recent accounts of developments in projection. See, for example, "The Projected Image in Contemporary Art," a roundtable discussion with George Baker, Matthew Buckingham, Hal Foster, Chrissie Iles, Anthony McCall, and Malcolm Turvey, ed. George Baker, *October* 104 (Spring 2003): 71–96.

nally existed as projected slides. The piece depends on the additive effect of slides showing tract housing under construction, but it does not produce a sense of fluidity between units; each picture is broken from the last by the separate slots of the turning carousel. Pointing to Marcel Duchamp's famous *Nude Descending a Staircase* (1912), Graham wrote that it was "the analysis of motion which first moved artists." In his own case, the isolated still became a kind of visual anchor, a cumulative fragment in the work's progression.

The first audiences to walk into the space of slides discovered not only images thrown onto the wall but also the obvious presence of the mediating technology employed to disseminate them. Rather than remaining stationary, as if contemplating a two-dimensional object hanging in its frame, viewers were invited to engage the work physically as they passed through beams of light and around equipment. By the early 1970s, as Martin Friedman has observed, artists thought of their works "in environmental terms—as dominant elements of interior spaces—and they [were] as much concerned with the changing spatial and psychological relationships between observer and image as with the character of the image itself."[19] Though some slide works were made for large screens, many

20. At one time, "to project" meant "to work an alchemical transmutation by casting the philosopher's stone over base metal in the hope of turning an inferior amalgam into pure gold." Stafford and Terpak link the optical devices of projection in the seventeenth century to a "dialectical process of joining earthly to unearthly experiences." See Stafford and Terpak, *Devices of Wonder*, 82.

21. Rosalind Krauss's writing on James Coleman offers many insightful comments on the artist and his chosen medium. Krauss focuses on his exploitation of slide projection as a circular process, at once insinuating and refuting the idea of an accessible narrative. She explains this in part as an attribute of the carousel's circularity, which "finishes only to start again." Coleman's awareness of the medium's endless repetition as well as its capacity to deliver fractured and nonculminating sequences is played out in works conceived as a critique of the medium itself. See Krauss, ". . . And Then Turn Away?" (1997) and "Reinventing the Medium: Introduction to *Photograph*" (1999), both in *James Coleman*, ed. George Baker, October Files 5 (Cambridge, Mass.: MIT Press, 2003).

responded directly to the configuration of existing architecture. In *Land/Sea* (1971), for example—a six-carousel installation suspended from the ceiling—the Dutch artist Jan Dibbets creates an extended panorama spanning two adjacent walls, altering the space as well as elevating the images. (The work is very consciously *not* at eye level.) Other works, such as Anthony McCall's *Miniature in Black and White* (1972), assert the machine as part of the work—the sound of the carousel clicking, the projector stand, and the rays of light cutting through the room. These physical elements, so obviously necessary to the projection of slides, made the images themselves seem all the more immaterial. As much as they generated a relationship between the viewer and the projection, these works provided a lesson in mediation and a means by which the technology itself could function as subject matter.

Breaking the flow of projected images—and, consequently, our desire to read them as part of a logical progression—is central to the work of James Coleman. To "project," which originally referred to the process of transforming base metal into gold,[20] is, for Coleman, as much a state of mind as a function of an apparatus. In *Slide Piece* (1972), for instance, the same image of a car park in Milan is subjected to various interpretations (or projections) delivered through a succession of human voice-overs. Though each one is different, all accounts are plausible. The viewer standing in a closed chamber looking at what seems at first to be an image purveying a straightforward, singular truth falls deeper and deeper into its nuances and contradictions. In this early installation, Coleman couples the elusive properties of the slide as a thin piece of transparent film with the density of the image itself as a container of meaning that can change, depending on who is speaking. Although Coleman captions the work by adding an acoustic version of text, he refuses to make any one description more or less authoritative than the others. Significantly, he designates the slide a "piece"—a term customarily used to equate an object with art (as in a "sculptural piece") as well as to signify fragmentation (as a part of something). Coleman's title reminds the spectator that the meaning of the image lies not in what it depicts but rather in its demonstration that things are not always what they appear to be. What we call "content" is inherently an abstract projection derived from various physical and psychological sources.[21]

The act of complicating the terms of photography's apparent objectivity came about as artists like Coleman began to explore how the display of images, particularly as slides, informed their reception. Many of Coleman's peers viewed pho-

Anthony McCall, drawing for
*Miniature in Black and White*, 1972

tography with a great deal of skepticism, leading to number of experiments that analyzed the way in which cameras both record and distort information. Photography represented an intriguing conundrum: while artists needed the camera to document their more transient artworks, they realized that the very process of *making a picture* could potentially reinscribe a visual tradition they sought to resist. One possible response was to make photographs that looked unartistic, at times even awkward, and disseminate them through means *other* than the fine-art photographic print. Slide projection was ideal because it was so utterly familiar and utilitarian and yet provided a distinct means to explore and manipulate information held on a transparency. The slides in Graham's *Homes for America,* shot with an Instamatic camera, are consciously straightforward, as if made by an amateur. Yet as projections they ruminate on the theme of mass production— of houses as well as of unfolding pictures. Barry's slide piece *Reflections* (1975) contains similarly understated pictures filled with mirrors and windows. These slide images, totally without pretense or grandeur, are transformed by the projector, redefined by its capacity to sequence and enlarge. As the basis for most slides, the still photograph is always a fragment of something larger, abstracted from the visible world yet inseparable from its split-second permutations. Slide projection offered a way to reattach that severed moment in time to a new reality, one defined by the structure of a carousel.

If any feature linked these various examples of early slide projection works, it was the notion of infinite and regulated seriality made possible by the carousel's endlessly turning wheel of images. Marcel Broodthaers, an artist whose interests centered on the ways in which art is analyzed, treated slides as the penultimate means of reproduction and repetition. His *Bateau Tableau* (1973), a slide piece based on the visual dissection of a nineteenth-century maritime painting, underscores the functional use of slides as a copy of something else that is then subjected to an ongoing cycle of display. The standard round eighty-slot carousel, available by 1961, generated images on a continuous loop, a quality that artists immediately recognized and exploited. But instead of creating dramatic narrative arcs, many focused instead on the regulated succession of frames in which no single element is any more or less important than the others. Each image retains its status as an individual unit and each fills an allotted space and time, which ends when the machine blinks and the next slide appears. Graham, Barry, and Broodthaers all took advantage of the medium's self-evident lack of seamlessness and its plodding, deliberate manner. They liked the way a carousel of

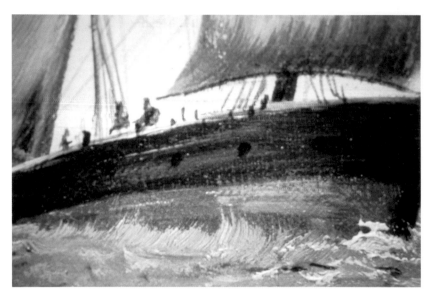

Marcel Broodthaers, still
from *Bateau Tableau*, 1973

slides performs a blatant refusal of finality. A sequence of projected slides produces an experience of unfolding images that ends only to begin again.

A drawn-out experience of time emerges from these early slide works, devoid of people and overt narrative. In an era when artists could easily have chosen faster media to capture the rapid pace of contemporary life, slide projection was comparatively deliberate and slow, filled with breaks and ruptures. Lothar Baumgarten's *I Like It Here Better Than In Westphalia (Da Gefällt's mir besser als in Westfalen) ELDORADO (Voltaire's Candide)* (1968–76), for example, promotes an extremely gradual viewing process accompanied by a sound track filled with the calming sounds of nature. Developed through an arrangement of slides fading and dissolving, the work presents a landscape, initially pristine, that over time proves to be polluted. As a version of the moving image, works like *I Like It Here Better Than In Westphalia* were virtually antithetical to the commercial film, with its wide-screen monumentality, cohesive story line, and temporal compressions. Slides offered a way to isolate and emphasize discrete moments while nudging them forward in time. This tension between past and present, and between photography and film, gave slides a duality that was difficult to approximate with other media. As Conceptual art demonstrated, slide projection was an old technology that, when retrofitted by artists, became a new means of experiencing the elasticity of time through still pictures appearing and disappearing on the wall.

PERFORMANCE ART

The emergence of performance art coincided with the rise of slide projection as a medium for searching out the relationship between transient artworks and their visual representation. Projected images from slides appeared as early as 1952 in the groundbreaking *Theater Piece No. 1* at Black Mountain College, North Carolina. For John Cage, who organized the multifaceted event, slides func-

22. "At one end of a rectangular hall, the long end, was a movie and at the other end were slides. I was up on a ladder delivering a lecture which included silences and there was another ladder which M. C. Richards and Charles Olson went up at different times. During periods that I called time brackets, the performers were free within limitations": John Cage, quoted in *Black Mountain College: Experiment in Art*, ed. Vincent Katz (Cambridge, Mass.: MIT Press, 2003), 139.

23. While the slides in this exhibition were made with a 35 mm camera, artists such as Mel Bochner and Mark Boyle mounted other substances for projection. This material, an important component of slide work, warrants further study.

tioned within a structure of "time brackets"—actions happening at coordinated intervals and locations.[22] Though slides were but one element in this formative work, their presence at Black Mountain College signaled their potential compatibility with performance as a spatial and durational art. In some ways, the performance art of the late twentieth century came to resemble a *Gesamtkunstwerk*, a Wagnerian concept often used to describe work that combined radically different media, including music, dance, film and poetry, in the same setting. Performance art extended the idea of blending creative practices into everyday life, with the artist's body and behavior taking on ever more prominent positions as instigator, actor, catalyst, and subject. Exploring the limits and the possibilities of art, purveyors of performance escaped from the studio to find new sites of discourse and activity where they could freely experiment with how and where they made their work. Materials and locations culled from the experience of daily life—a city sidewalk, a nature preserve—replaced paint and paper as the principal means of creative production. Slides served to represent and document those places and give them new meaning as subjects. Seeing a performance firsthand dictated one kind of viewing experience; observing the event in the form of projected slides was quite another.

Artists performed *with* and *for* slides inasmuch as they used the medium as both backdrop and document. Most worked with slides made from a still 35 mm camera; others painted on their slides or inserted substances like bodily fluids into the slide mount for projection.[23] As artists found ways to circumvent traditional art museum audiences, slides served to introduce new visual content to the stage of performance while enlivening the atmosphere with a constant flow of flashing images. Carolee Schneemann, Yvonne Rainer, and Marina Abramovic, for example, deployed slides to elaborate upon what they performed with their bodies, often incorporating images drawn from popular culture, history books, films, and the mass media. The choice of these visual materials, particularly those representing the female body, infused these performances with strongly political meaning. Indeed, critics like Lucy Lippard viewed slides as vehicles for commentary and social action on the subject of gender. In 1970, she led the Ad Hoc Women's Committee in a protest against the virtual exclusion of women artists from that year's Whitney Annual. The group undertook various measures to voice their collective dissent, but "the most inventive ploy," Lippard wrote, "was stationing a small generator in the street . . . to run a slide projector displaying enlarged images of women's art and demands for '50% Women' on

the Whitney's façade. . . . [The] images battering at the outside walls of the museum in resistance to the absence on the inside walls was a powerful strategy."[24] Such interventions reinforced the role of slides as mediators of information that could, when joined to the physical presence of the artist's body, temporarily but forcefully create a site for public discourse. The projection of slides, as Lippard and her colleagues demonstrated, offered a direct way to communicate pressing issues, be it on a stage or on the outside wall of an art museum. Indoors, artists used slides to scatter images across space, bridging the distance between artist and artwork, spectator and image. The medium thus played upon and accentuated one of the most significant aspects of performance art: it was a form of human discourse, promoting a dynamic interaction between people, politics, and art.

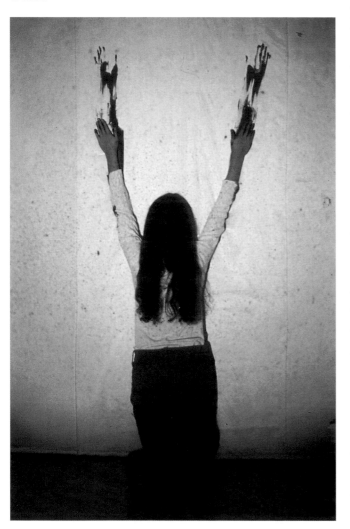

Ana Mendieta, still from *Untitled (Body Tracks)*, 1974, a performance at the University of Iowa

Not surprisingly, slides became an important means by which to document the progressive stages of performance art. Ana Mendieta, for example, chose the slide medium to record her actions; it could reestablish the scale, order, and, perhaps most significantly, the transience of artworks that originally existed as brief physical encounters. Her attention to everything ephemeral, including such materials as grass, mud, and sand, was communicated through slides that were as fleeting on the wall as the organic formations they depicted from real life. For *Body Tracks* (1974), Mendieta's companion at the time, Hans Breder, photographed a process in which the artist dragged her arms, covered in animal blood, down a whitewashed sheet. The work, informed by the ideas of sacrifice and transcendence, asks the viewer to consider the meaning of impermanence as a human condition, one that the artist suggests through the act of making stains with her body—literally, traces of her being. For Mendieta, slides functioned on both practical and symbolic levels. She knowingly produced visual documentation that would enable future audiences to see her work. And she exploited a medium that would affirm the overriding principle of her art—its investment in the idea of time's passage.

Robert Morris, *Continuous Project Altered Daily*, 1969. From the edition *Artists and Photographs*, 1970

Artists addressed the simulation of unfolding experience by using different methods and slide projection technologies. The automatic dissolve, for example, offered a system for layering images so that they appeared to move in and out of focus, blurring the lines between frames. This effect required at least two carousels wired to a common control unit. Though the potential of automated slide shows was not fully realized until the 1980s, the technology was available in the 1960s, opening up the possibility of combining images in seemingly fused sequences. In addition to fading, the dissolve permitted artists to incorporate multiple slide trays, adding significantly to the number of images constituting any one work. This move away from the single image as an artistic centerpiece reflected a wider preference for group compositions in the 1970s. In the *Artists and Photographs* portfolio, for example, the serial configuration dominates in pictures that document actions by Robert Morris, Richard Long, and Christo, among others. For artists like David Hockney, such experiments with photography as a cumulative medium represented an opportunity to come "closer to how we actually see . . . not all-at-once but in discrete, separate glimpses."[25] Slide projection provided a system for ordering and recombining those glimpses to form new perceptual realities.

The fact that the projection of slides involves the task of organizing images into sets of relationships led some artists to explore the medium as an additive process of visual construction. As Dennis Oppenheim discovered, the formation of a slide work involved a number of stages, from the taking of pictures to their placement in the slide tray to the on-screen time devoted to them—all of these being conditions subject to manipulation. His control of such variables is clear in *Ground Gel* (1972), a double-carousel work that portrays the jagged clockwise motion of two figures, Oppenheim and his daughter, spinning in a circle until their bodies appear merged. To make the work, an action was photographed from above, forming a collection of images that could be combined in any configuration. Instead of adhering to the initial chronological order of the exposures, he applied a new rationale to their arrangement, resulting in a deliberately imperfect flow of movement as the sequence progresses. All the while, we are conscious of the artist treating the slides like a deck of cards, reshuffling reality with each hand. The very lack of seamlessness makes this work dizzying, an effect furthered by the lateral projection of images that began as aerial views.

24. Lucy Lippard, "Biting the Hand: Artists and Museums in New York Since 1969," in *Alternative Art New York: 1965–1985*, ed. Julie Ault (Minneapolis: University of Minnesota Press in collaboration with the Drawing Center, New York, 2002), 99–100.
25. David Hockney quoted in *The Spoken Image: Photography and Language*, by Clive Scott (New York: Reaktion Books, 1999), 228.

Dennis Oppenheim, installation
view of *Ground Gel*, 1972

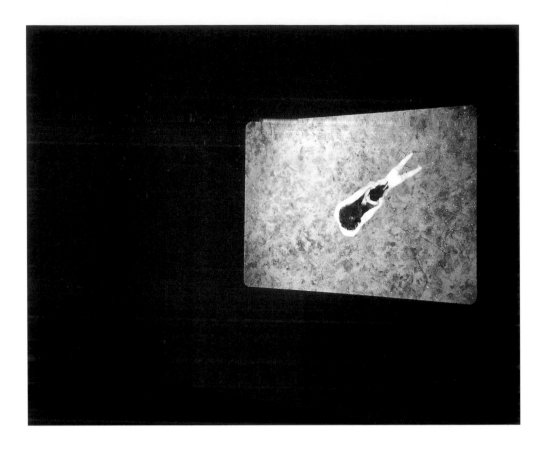

Oppenheim felt no need to imitate the appearance of his original action, the spinning itself. He knew that slides would change the look and feel of this event dramatically.

The easy handling and editorial flexibility of slides made them extremely popular in the screening rooms, clubs, and noncommercial galleries that emerged during the late 1970s and early 1980s, especially in New York City. Removed from the confines of the pristine, white-walled art museum, these spaces functioned as meeting places where artists could see new work, exchange ideas, and make a little money. The then-affordable Lower East Side of Manhattan was a magnet for all types, including writers, poets, actors, and musicians—artists whose interests frequently cross-pollinated.[26] For a time, this neighborhood was the hub of the "alternative" art world whose trends might have been too risqué for a more conservative midtown art-buying audience. Artists ran or organized many of these experimental venues or performed in their own ad hoc theaters

26. On the politics of the Lower East Side art scene in these years, see Alan Moore and Jim Cornwell, "Local History: The Art of Battle for Bohemia in New York," in *Alternative Art New York*, ed. Ault, 321–65.

27. A listing under the title *Boiled Lobster Color Slide Show of Crab Lagoon* in a Millennium Film Workshop pamphlet from February 1985, initiated by "J. S.," explains, "One of the highlights of the 1983–84 Millennium season were the programs featuring the films of Jack Smith. He returns on these two evenings with programs of slides and performance. Smith, the almost mythical filmmaker & actor, whose work influenced a whole generation, will present two shows of new slides and performance, which features Sinbad Rodriguez and Yolanda La Pinguima. The programs are entitled, DEATH OF A PENGUIN and will each last two hours."

28. See Tom Holert, "Nan Goldin Talks to Tom Holert," *Artforum International* 41 (March 2003): 232.

29. Ibid.

and lofts. Jack Smith, famous for his transgressive performances and "boiled lobster color" slide shows, became a central figure whose work and lifestyle embodied a humorous disregard for all standards of normalcy, including those imposed by art. Smith's performances were unforgettable, as were his various on-camera personae: aging drag queen, clean-cut dandy, prince of darkness, and many others. A consummate showman, he posed for the camera with a flair for overblown drama, biting satire, and visual seduction. Equally important to his creative process was editing: he often remixed his slides and sound tracks while screening them, causing huge delays for late-night crowds. The slide shows or "jams" held in his loft and at the Millennium Film Workshop never repeated the same material.[27] Adding or subtracting pictures spontaneously, he produced unique programs for his small but devoted following.

The production of live shows featuring slide images, music, and, of course, the performer moved from the private sphere of clubs to a larger public—especially art-world public—with *The Times Square Show* (1980), an exhibition held in an abandoned Manhattan massage parlor. In addition to a Jack Smith performance piece, it included one of the most memorable slide works of the era: Nan Goldin's then-untitled *Ballad of Sexual Dependency*. Since moving to New York from Boston in 1978, Goldin had appeared for friends and club regulars around the city with her impromptu slide shows.[28] A voracious chronicler who took intimate slides of friends and lovers, she presented the work first at Frank Zappa's birthday party in 1979 and then at New York venues such as the Rock Lounge, the OP Screening Room, and others. The personal, spontaneous nature of these performances—in which the artist would hold the projector in one hand and load slides with the other—attracted an audience of friends, many of whom constituted her core subject matter. *The Times Square Show*, however, brought *The Ballad* to a larger constituency, and to one woman in particular, Maggie Smith, who inspired the artist to consider the social and political implications of this work as it examined "the difficulty in coupling, the struggle between autonomy and dependency, sexual addiction."[29] Over the next few years, Goldin reworked the slide sequences, trying out additions, omissions, and varied combinations of images to address these complex issues. In some ways, the formulation of Goldin's *Ballad* became a consolidation of personal narratives set to a rock-opera sound track, including music from Jim Jarmusch's film *Stranger than Paradise* and Bertolt Brecht and Kurt Weill's *Threepenny Opera*. As a performance, the piece was a document of private life among friends, infused with

Nan Goldin, flyer advertising
*The Ballad of Sexual Dependency,*
ca. 1985

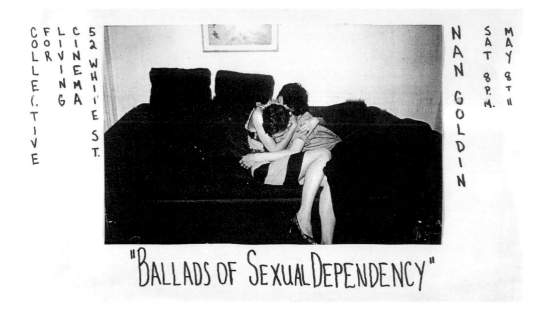

"BALLADS OF SEXUAL DEPENDENCY"

a brutal honesty difficult to attain with biological kin. Its participants gained on-screen celebrity even as they suffered publicly. Marvin Heiferman, a former dealer and producer of the slide show, recalls that *The Ballad* "was all about breaking with photographic and cultural restraint. It had the drama of an opera unfolding synonymously with AIDS, and is a work of vulnerability and passion."[30]

The autobiographical dimension of slide-based performance was rooted in the ways in which artists adapted personae in their pictures and on stage. *The Ballad of Sexual Dependency* came into being as an extension of Goldin's private life, and she imparted a certain intimacy to it when performing in the casual atmosphere of bars and clubs. Oppenheim also chose subjects close at hand: his partner in *Ground Gel* was his young daughter, Chandra. As performance documentation, these slide works are distinguished by their intimate and psychological nature. Their subjects posed not just for the camera but also for a close associate or relative standing on the other side of the lens. When their gestures and expressions were edited for public consumption, subjects almost inevitably acquired an expanded, complex range of meanings. It seems appropriate, for example, that Goldin's images of people's fantasies and sorrows should be realized as short-lived projections. Photography itself, in Roland Barthes's estimation, is a performative act that requires the knowing subject to pose (indeed, project) for the camera, anticipating how he or she might look and be remembered as an

30. Marvin Heiferman, telephone interview by Darsie Alexander, 20 May 2003.
31. Roland Barthes, *Camera Lucida: Reflections on Photography*, trans. Richard Howard (New York: Hill and Wang, 1981), 10.
32. See Brougher, *Art and Film Since 1945*, 119.

image.[31] An artist like Smith performed to excess for the camera as the flamboyant subject of his images and the idiosyncratic narrator who put them in sequence. To experience these images as larger-than-life self-projections is to understand the close alliance between performance and slide shows. Projected slides made possible the public viewing of private acts even as they reaffirmed the transient nature of human relationships. Slides gave performers, even reluctant ones, an audience.

Serial and often personal, the slide shows of performance artists reflected the return to narrative entering contemporary art in the late 1970s and 1980s. This shift partly developed as a reaction against the cool intellectualism of Conceptual art as well as a desire to go back to the problems of depiction and human representation.[32] Moving away from the hermetic art of the 1960s and 1970s, artists began to structure their works around issues of subjectivity that often involved emotional, psychological, or social dilemmas. The change was evident in the appearance of more complex modes of narrating—through the incorporation of music, for example, or in the impulsive on-the-spot sequencing of the producer or performer. Beyond that, people became more visible in the pictures, which brought their movements, poses, and interactions to the fore with greater intensity. The human presence in these works contributed to their narrative power as mediators of specific lives and stories and to the theatricality they assumed when looming large on the walls of buildings and art galleries.

## PUBLIC PROJECTIONS

Significant developments in art during the 1980s affected the scale and appearance of slide works. A growing preoccupation with the workings of the mass media, from billboards to television, sparked deeper investigations into art's capacity to critique popular culture—in part, by appropriating its look. The particular function of the camera in generating images for popular consumption became ever more present as the subject of art, especially in works that imitated the slick veneer of advertising. Sherman's photographs, for example, which began in the form of small black-and-white prints, grew enormously in size, color, and detail, with the artist herself taking on more extreme roles and poses. Unlike many images from the previous decade, which possessed an off-the-cuff casualness, photographs and slides of the 1980s seemed to reflect a higher level of professional finish. The emphasis increasingly shifted from works that embraced

accident to those in which the artist exercised control over every facet of the work's evolution, from staging the subject matter to overseeing the final print.

The common view that art of the 1980s revealed a greater fascination with spectacle is upheld by the developments in projected slide art during the period, especially those works created for large outdoor settings. As artists looked for ways to interact, visually and critically, with the mass media, they turned to urban centers, where a constant flow of pictures, slogans, and advertisements saturated space. The vistas and edifices of the city became a rich playing field—a place where artists' work would be seen in the course of daily life, on the street. Outside the confines of the museum or art gallery, artists used architecture as large screens on which to deliver provocative messages. The monumental projections of Krzysztof Wodiczko, whose work received great critical acclaim in the 1980s and 1990s, disrupted the cityscape of late capitalism by introducing ominous images onto buildings in the dark of night. Missiles, chains, and clenched hands ran along the outer walls of public buildings, illuminating the sites from powerful ideological vantage points. Located amid the social chaos of the street, these images turned the familiar and ordinary into the foreboding, forcing passersby to think twice about the seemingly innocuous environments they inhabited every day. The resonance of the projections stemmed, in part, from their temporal nature, for they typically appeared for a few nights and then vanished. (Wodiczko worried that if the projections were left on too long, they would be seen "as decoration.")[33] The aim of such works was not to sell anything; they proffered only critical currency on an unprecedented scale.

Ironically, commercial slide shows contributed to the media saturation of public space. Kodak identified this phenomenon in 1979 when it published *Images, Images, Images,* a manual designed for computer programmers and audiovisual experts. The book championed the concept of multimedia—a catchphrase used to describe a variable combination of slides, film, and sound. Such shows were particularly popular at tourist destinations, information centers, and fairs throughout the United States, where potential customers would be stimulated to look and buy. According to the book's anonymous authors, the success of a multimedia show depended on its capacity to deliver these elements seamlessly and simultaneously, so that "our eyes . . . focus on dozens of objects in a matter of seconds. . . . Our mind begins to build an overall impression."[34] The new standard of perfection and repeatability established by the book seemed targeted at profit-making industries, but the general change in how slides func-

33. Krzysztof Wodiczko quoted in *Public Address: Krzysztof Wodiczko,* by Peter Boswell, exhibition catalogue (Minneapolis: Walker Art Center, 1992), 20.

34. *Images, Images, Images: The Book of Programmed Multi-Image Production* (Rochester, N.Y.: Eastman Kodak, 1979), 15.

35. Robert Morgan, "Tales from the Dark Side," *Afterimage* (Summer 1987): 25–26. Morgan was reviewing the exhibition *Dark Rooms* at Artists Space, New York.

36. McCall, in "Projected Image in Contemporary Art," 76.

37. Foster, in ibid., 73.

38. See Eastman Kodak press release, 26 September 2003.

39. Susan Sontag, "Regarding the Torture of Others," *The New York Times Magazine*, 23 May 2004, 25–29.

tioned as part of a complicated system of programmed visuals had obvious implications for artists. Many continued to make slide projections the old-fashioned way—with a camera, loop, and light table—but as the production of commercial AV shows became more sophisticated, other artists sought to produce a more cinematic experience for art audiences. The simple, solitary clickety-clack projector that had satisfied 1960s and 1970s artists just didn't seem to relate as directly to the new mediated reality of contemporary society.

The enhanced capacity to streamline slide projection coincided with its growing presence in the institutions of the art world. Goldin recorded *The Ballad of Sexual Dependency* as a self-contained piece with a sound track in the mid-1980s for the Whitney Museum of American Art. Coleman's work, too, moved away from its more modest origins to become a sophisticated audiovisual assemblage of large, intensely colored images. Such works gained recognition not only among collectors and curators but also among audiences fascinated by the sensorial appeal of cinematic images and absorbing sound. In 1987, a reviewer for the journal *Afterimage* noted a "rash of media installations, and slide projection in particular."[35] Even as some artists like Wodiczko worked outdoors with their projections, slide shows were increasingly relegated to closed interior spaces, where the experience of projection could be controlled. Total immersion in "the elsewhere of the moving image,"[36] a state so common to movie fans, now became available to art audiences in the darkened galleries of museums. *Projection 4 (P)* (1997) by Peter Fischli and David Weiss, for example, presents dense and overblown nature scenes slowly dissolving into one another, holding the viewer in suspense as double-exposed slides give way in an endless cycle. The work is flooded with detail, leaving no visual gap or prolonged interval to freeze its continuous and engrossing motion.

The gradual switch from works that critiqued technology to those in which mediating devices were virtually invisible reflected a broader transition in projected art forms. In the 1960s and 1970s, artists had engaged in a close analysis of their medium—they were "treating the film reflexively, as material; working with the apparatus; being concerned with the embodiment of the viewer, the parameters of space."[37] By the 1980s and 1990s, these preoccupations with the physical and even social aspects of slides gave way to a greater focus on attaining a high level of image quality and acoustic purity to engulf rather than articulate the space of the viewer. Museums are filled with moving images shown in dark chambers, where visitors enter, sit in silence, and leave. There is little interaction

Peter Fischli and David Weiss,
*The 59th Minute, Busi (Kitty),*
16 April–30 May 2001, flatscreen
billboard display, New York's
Times Square

(except for occasional whispers among friends), and move-
ment through the space tends to be limited. The rowdy
behavior at live club shows like those of Smith or Goldin on
the Lower East Side belongs to a distant past. The gap
between the slide show of the art museum and its modest,
accessible origins continues to widen. Kodak's announce-
ment that it will no longer manufacture slide projectors after
2004 makes that gap permanent.[38]

What caused the demise of slide projection? In some ways,
the answer seems obvious and specific. By the 1990s, com-
puter-controlled PowerPoint "slide shows" featuring easy-to-
manipulate images, graphs, and texts had come into
common use in all the areas where slide projection had once
held sway—classrooms, museums, businesses. But, more
broadly, the end of slides is the outcome of a digital world
that renders still 35 mm transparencies antiquated. Electron-
ically equipped kiosks accessing databases of art images have
replaced resource rooms, and even the direct contemplation
of museum collections has stepped further away; five-story
moving images now wrap around the screen-skins of build-
ings, and flat screens flash video ads to pedestrians entering
subways. Even newspaper illustrations are often taken from
digital sources and video, frozen not from life but from an
increasingly dominant televisual experience. Freed from the
matrix of the film negative, these images can travel across a wide range of plat-
forms: the Web, personal laptops, image-carrying cellular telephones. The com-
puter hosts an endless repertoire of once-private pictures that now circulate in
the ether of Webcasts and photoblogs. The accessibility of unedited images has
made for at least one international crisis, when U.S. soldiers used e-mail to send
home photographs taken of abused Iraqi prisoners. On 12 May 2004, those gov-
ernment officials who had missed seeing the pictures on television got a slide
show in which they confronted a stunning spectacle that had been delivered up
the chain of command and out into nearly every household in America.[39]

Nonetheless, slide projection's role in bringing this phenomenon of moving
images into the sphere of art should not be overlooked. Projected slides, particu-
larly after the advent of the circular carousel and the automated projector,

40. Stephen Bann, "Environmental Art," *Studio International* 173 (February 1967): 78.
41. Foster, in "Projected Image in Contemporary Art," 73.

attracted artists in large part because of their movement, transience, and immateriality. But no matter how quickly the intervals between frames progressed in a carousel, slides were ultimately static objects. Even as technological advances made them easier to combine, sequence, and accelerate, slides could not produce the same seamless blending as film. And, needless to say, the technology was proving to be a detriment. The much-celebrated switch from hand-feed to automated systems in the early 1960s certainly allowed artists greater creative flexibility, but the fallibility of slide projection (jammed slides, blown bulbs, and so on) made for increased frustration among even the most die-hard users. Finally, the superiority of slides for reproducing color became doubtful. By the 1970s, cheap color prints had become widely available, making the slide medium less necessary as a means of capturing the immediacy of a brightly illuminated world. Slides fade quickly, too; their longevity is generally accepted to be five to seven years. Yet none of these flaws, as apparent to artists forty years ago as they are today, inhibited experimentation with this medium when it first captured artists' imaginations. Most didn't mind the occasional accident or technological failure that came with slide projection. To paraphrase the experimental arts writer and cinematographer Jean-Jacques Lebel, the best artistic happenings invariably court catastrophe.[40]

What are the consequences of technological obsolescence for artists? "There are usually two dynamics at these new technological moments," says Hal Foster. "There are artists who want to push the futuristic freedoms of new media, and others who want to look at what this apparent leap forward opens up in the past, the obsolete."[41] In today's world, both tendencies are in evidence, though recent works incorporating projected slides are decidedly nostalgic in tone. Jonathan Monk's slide piece *One Moment in Time (Kitchen)* (2002) evokes the bygone family slide show, with words replacing images as suggestive fragments. And Ceal Floyer's *Auto Focus* (2002), disarmingly simple yet symbolic, shows the lens of the projector moving in and out of focus in a futile attempt to grab an image that is not there. Not surprisingly, these works also make reference to the history of slides *as art* in their evocation of 1960s Conceptualism—particularly in their use of straightforward machinery, elusive images, and ceaseless repetition. Contemporary artists now regard slides not so much as a way of projecting images in space and time but as a means to turn back the clock. As a medium for preserving and projecting histories, slides have always excelled at accomplishing this task.

We need objects?

One may argue that an extensional object is merely designated, i.e. it
is directly referred to in a Fregean context, it is distinct from 'idea'
and the set of properties which make it up.   The 'mode of presentation'
of that object may be said to subsist somewhere between the concept, if
you like, or idea (of it) and its simple designation  -  its simple picking
out, distinguishing from others.   It is that which is designated.   The
mode of presentation, or object constituted in terms of mode of present-
ation is not the object itself in this extensional sense, nor is it anything
entirely 'subjective' or, if you like, accountable only in a private
experiential or ideational domain.   In the Fregean system one can
effectively compare the 'object', the 'mode of presentation'.   I associate
object and the ideational one with the table, the cube  -  the cube as a
relational entity presented sensorily in a certain way, and the retinal
image of each individual spectator.

Intention as 'the object in a certain mode of presentation'.   For reasons
of antipsychologism, Frege wanted to make sure that the object, in the
extensional sense should neither be confused with its mode of presentation
nor the idea of it.

# SAVING PICTURES

*Charles Harrison*

1. *54–64: Painting and Sculpture of a Decade,* exhibition catalogue (London: Tate Gallery, 1964), 7.
2. Donald Judd, "Specific Objects," *Arts Yearbook* 8 (1965): 74.
3. Among the major relevant surveys were *Op Losse Schroeven (Square Pegs in Round Holes),* Stedelijk Museum, Amsterdam, March–April 1969; *When Attitudes Become Form,* Kunsthalle, Berne, March–April 1969, and I.C.A. London, September 1969; *557,087,* Seattle Art Museum, September–October 1969; *Art in the Mind,* Allen Art Museum, Oberlin College, Ohio, April–May 1970; *Conceptual Art and Conceptual Aspects,* New York Cultural Center, April–August 1970; and *Information,* The Museum of Modern Art, New York, July–September 1970.

Art & Language, *38 Paintings (Painting No. 11),* 1966, photostat

In the early twenty-first century, a visitor to an exhibition of modern art can expect to be confronted by works in a wide range of different media—but perhaps by few that would fit comfortably within the categories of painting or sculpture. In the context of the transatlantic art world, however, as late as the mid-1960s, substantial surveys of recent and current art could still be mounted that resolutely assumed the practical centrality of painting and sculpture, and the effective marginality of everything else. Witness, for example, the major exhibition *54–64: Painting and Sculpture of a Decade,* organized by the Calouste Gulbenkian Foundation and presented at the Tate Gallery in London from April to June 1964. The selectors claimed, without qualification, that the exhibition "illustrates the art of the last ten years."[1] Yet, as Donald Judd asserted in 1965, "Half or more of the best new work in the last few years has been neither painting nor sculpture."[2] By the end of the decade, when a new avant-garde was surveyed in a number of international exhibitions, only a small minority of the numerous works included could plausibly be described as either painting or sculpture.[3] We are now so well accustomed to variety in the means of distribution and display of contemporary art that it is easy to forget how suddenly and how dramatically that variety was established as the norm.

Significantly, the earliest works in *SlideShow* derive from the late 1960s, when this change in expectations was effected. And although the show is devoted to works in one specialized photographic medium—and includes some work more readily associated with the history of photography than the history of art—it is primarily conceived of as an art exhibition. Two questions naturally arise. First, how should we explain the emergence of a wide number of artworks in this particular medium during the specific period in question? Second, why should these enterprises be surveyed as works of art within an art museum, rather than being treated, say, as footnotes to the development of photography, or as archived lectures or demonstrations? The two questions are clearly inseparable:

4. Michael Baldwin (Art & Language), in conversation with the author, as cited in "Conceptual Art: The Aesthetic and the End(s) of Art," by C. Harrison, in *Themes in Contemporary Art*, ed. Gill Perry and Paul Wood (New Haven: Yale University Press in association with the Open University, 1994), 61. Compare the following, by an artist writing at what might be considered the moment of inception of modernism: "This new world, good or bad, which is trying to reach the light across our ruins, is like a volcano under our feet, and lets no one catch his breath again. . . ." The passage appears in the entry for 3 September 1857 in *The Journal of Eugène Delacroix*, trans. Walter Pach (London: Jonathan Cape, 1938), 599.

5. In "Greenberg on Criticism," a television program made in association with the course A315: Modern Art and Modernism, Open University, Milton Keynes, 1982.

6. I should make clear that in saying it was *open* to artists to maintain reference by such techniques, I mean just that. It is not my understanding that the conditions in question were coercive, or that artists—like Bonnard and Matisse—who failed to avail themselves of the resources of collage and photomontage during the 1920s were in some sense failing to live up to the demands of the age.

to explore the character of these works as works of art is to inquire into the historical conditions of their production, and vice versa.

It is by now an accepted convention of the history of modern art that a broad crisis in the culture of modernism occurred during the 1960s. This meant, in practice, that for an entire emerging generation, certain traditional assumptions about how a work of art was to be defined as such simply lost their regulative power. At the time, it seemed as though there had been a noticeable widening of distance where divisions tended ordinarily to occur, whether between generations, between teachers and students, or simply between people of different inclinations and commitments. The modernist account of the development of art had never gone unopposed, but by the early 1960s it had become dominant, even hegemonic—empowered in part by the international success of American Abstract Expressionism, to which it provided a telling intellectual complement. For all the resolute political individualism of the Abstract Expressionists themselves, that dominance was now inescapably associated with the exercise of American military and economic power at a time when there was widespread opposition to the war in Vietnam. Coincidentally, certain fault lines in the modernist account had become impossible to ignore, while overt fissures showed here and there on the surfaces of its subscribing institutions—on the walls of galleries and museums, in the pages of magazines, and in the studios of art colleges. Speaking of the business of learning how to be an artist in the mid-1960s, one witness has described modernism as "like a surface that wouldn't bear your weight; you'd try to put your foot down somewhere and that bit would just seem to break off and float away."[4] If these conditions seemed to offer freedom from certain restraints, they also left artists and critics alike exposed to some uncertainty regarding what might or might not count as a "work." Conceptualization of the resulting production required a considerable shift in terms of reference— and sometimes involved the establishment of terms of reference where none appeared to be given. (I write as one who was of an age to be caught professionally at the moment of change, confused and frustrated as meaning drained from an inherited critical vocabulary, and responding with an inarticulate fascination to the new work being done by my contemporaries.)

In the light of hindsight, it is clear that this crisis had been a long time in the making. Clement Greenberg, who did more than anyone else to codify a modernist theory of art, spoke of a "crisis of taste" that had been "ongoing since the time of Manet."[5] Indeed, we might conceive of the history of modernist art as a

Robert Rauschenberg, *Sundog*, 1962, oil and silkscreen on canvas

whole as a history of changes in understanding about what it is that makes a given object a work of art—or, to put it another way, changes in the descriptions under which the intentional character of an object is significant. Among the issues by which both artists and theorists were exercised for much of the twentieth century, two are of particular relevance to the work included in *SlideShow*: first, the shifting status of pictorial representations (that is, recognizable images of things in the world), and second, the question of the relationship between pictures and texts as it bears on the categorization of given works as works of art. Both may be subsumed under the more general question of categorization—of what are the conditions according to which some body of material or some phenomenon claims recognition as an individual work.

Almost a hundred years ago, during the second decade of the twentieth century, the inexorable decline in the cultural status of handmade pictures was marked by two coincidental developments in European art. The first was the initiation of the great modernist experiment of abstract art, under which it was proposed that for the purposes of art, pictorial representation was actually dispensable. The second—which may appear now as a kind of compensation for the first—was the introduction of collage and photomontage into avant-garde practice. From that point onward, while theorists of abstract art emphasized the virtue of its self-sufficiency, it was open to avant-garde artists who still intended explicit reference to an external reality to achieve it by incorporating texts or photographic images into their works.[6]

Until well after the mid-twentieth century, however, what justified the presence of these ready-made swatches of picture or text was their absorption within the formal complex defined by a framing edge, where that edge was necessarily conceived of as the edge of a painting. However closely it might be connected to the work of art, a photographic image or text encountered *outside* this limit was still liable to be consigned to a different and largely subordinate category, one associated not with the work's formal integrity but with the supposedly subordinate functions of record, documentation, and commentary. It might be thought that when Andy Warhol and Robert Rauschenberg adopted silkscreen tech-

Andy Warhol, *Nine Jackies,* 1964, silkscreen on canvas

niques in 1962, the result would be to accord the photographic image a more decisive role in the constitution of the work of art, but where the works succeeded, the reverse was actually the case. What followed—most surprisingly in Warhol's case—was an enhanced identification of pictorial record with canvas surface, to the advantage of the latter. One paradoxical effect, however, was to make all the clearer how dependent painting now was on photography where pictorial imagery was at issue.

During the 1960s, both still photography and film were certainly accorded a growing recognition as media with traditions and critical principles that were distinct from those of art and not necessarily inferior in their potential.[7] But professional photographers who intended that their pictures should be regarded for their own sakes still generally worked in black and white,[8] while even the minority who worked in color tended not to employ slide film for the purpose. (Helen Levitt's photographic work in the medium was first assembled for projection as a series of color slides as late as the fall of 1974. It is the highly exceptional status of this material that largely justifies its inclusion in the present context.) So far as slides were concerned, there was thus little occasion before the late 1960s to question their status as convenient means of reproduction. Given that transparencies require some means of transillumination, they were not even suitable for use in collage or assemblage. In the broad field of artistic culture, they served artists and dealers to record and to advertise their wares, and art historians and archaeologists to illustrate their lectures. Outside that culture, they were associated with technically "advanced" snapshots of children and vacations, projected ad nauseam to forbearing audiences of family and friends.

Intentional traces of these various usages survive among the earlier works in *SlideShow.* The artists who first conceived of artworks using slide film were not inventing a medium. Rather, they were positioning their enterprises within an already established world of reference—in part, perhaps, to draw in a range of content from the wider culture, whether by parodying the manners of the human sciences or by invoking the conditions and physical limits of human

7. Sotheby's in New York held its first major sale of photographs in 1970, when 570 lots fetched a total of $61,000. I am indebted for this information to Jori Finkel, "The Birth of the Photography Market: A Snapshot from the '70s" (lecture, Getty Research Institute, Los Angeles, 3 February 2004).

8. The Museum of Modern Art, New York, held regular one-person exhibitions of photographic work during the 1960s, but none was devoted to a color photographer until 1976, when William Eggleston's work was shown (ibid.).

activity. In his exposition of the Hotel Palenque, Robert Smithson strikes a virtuoso balance between the pedantic tone of an archaeological lecture and the bumbling narrative of "what I did on my summer vacation." Dan Graham's original photos for *Homes for America* prompt a comparable accompanying discourse, albeit one in which the social and artistic meanings of Minimalism will always be uncomfortably related. Marcel Broodthaers's *Bateau Tableau* has the camera crawling over every inch of a painter-journeyman's marine as though for a public lecture on some recently discovered masterpiece. Jan Dibbets's *Land/Sea*, for all its formality, locates its spectator at the beach. Dennis Oppenheim's *Ground Gel* opens with what might be taken as a snapshot of father and daughter playing, though it rapidly proceeds quite beyond the predictable expectations of family and friends.

For these artists, the attraction of color slide film may have been due, in part, to its relative technical innocence (so far as the history of art was concerned), its manifest unsuitability as a component of collage, and its practical association with documentation rather than self-expression. But their recourse to the medium also evokes a larger issue within the broad "crisis of modernism" as it worked itself out in the art of the later 1960s and early 1970s. Given the particular character of slide images as projections on a continuous surface, their exploitation for the purposes of art is evidence that certain restricting intellectual conditions had been overthrown. I noted above that until after the mid-twentieth century, the incorporation of a given picture in the scheme of an artwork normally required its inclusion within a framing edge. Of course, a wealth of experiments and adventures before the 1960s went "beyond the frame," but those works still tended to assume the power of that norm from which they established their avant-garde distance. The evidence shows that by the end of the decade, that assumption no longer held.

Crucially, if the power of arbitration between aesthetic and non-aesthetic worlds had ceased to be associated with anything like a framing edge, or, more generally, if the aesthetic properties of an object ceased to be necessarily identified with its physical properties, then it would surely follow that the distinction between art object and documentation could no longer be so straightforwardly applied, if it could sensibly be applied at all—with implications for a host of other hierarchical distinctions by which the concept of fine art had customarily been protected. And of course this was indeed most markedly and suddenly the case where the art and art theory of the later 1960s were concerned. As Arthur

9. Arthur Danto, *After the End of Art: Contemporary Art and the Pale of History* (Princeton: Princeton University Press, 1997), 125.
10. The *locus classicus* for this latter position is Michael Fried's impassioned essay "Art and Objecthood," first published in *Artforum* 10 (Summer 1967): 12–23.

Danto has observed of the modernist art-historical narrative associated with Clement Greenberg, "It came to an end when art came to an end, when art, as it were, recognized there was no special way a work of art had to be."[9] These were the conditions under which Graham's *Homes for America* could not only be conceived as a slide sequence for the exhibition *Projected Art* in 1966 but could also migrate to the pages of *Arts Magazine* in the form of a printed article, be recomposed into the layout board now in the Daled Collection, and finally reappear in 1971 as a color lithograph published by Nova Scotia College of Art. They were the conditions under which Smithson must have conducted his initial photographic tour of the Hotel Palenque in 1969, with variant practical outcomes possibly in mind—among them, perhaps, the spoof-lecture-as-artwork for which he actually employed his thirty-one slides some three years later. And they were the conditions under which such hybrid forms as those of Jack Smith and James Melchert developed and flourished in the hinterland between art and theater, art and film, and art and performance.

One explanation for artists' use of slide projection at this particular period, then, is that it served to circumvent precisely those problems of categorization to which an aura of anxiety and prohibition had for some while been attached. In the modernist criticism of the 1960s, for instance, the incursion of language and literature into art was generally regarded with deep suspicion, while the installational, the theatrical, and the environmental were associated with a high potential for aesthetic damage or adulteration.[10] But in the works in *SlideShow,* no disturbing issues of critical principle seem to be raised by the use of language, either where text is combined with pictures or where it alternates with pictures, or even where it is used instead of pictures—as in the case of Jonathan Monk's *One Moment in Time (Kitchen).* Whatever it may be that establishes the autonomy of the individual projected work, it cannot be the formal integrity of its surface. It is also in the nature of the medium that it admits of contrast and comparison. A work such as Robert Barry's *Reflections* depends for its effect precisely on the different signifying characteristics of pictures and words and on the pattern of overlapping suggestions that develops through their alternation. We may well be able to imagine words or pictures that would be inconsistent with the sequence and that would violate its integrity if included. Indeed, it is through intuitions of this kind that we explore the limits of specific compositional techniques and, in doing so, come to an understanding of their distinctive character. Clearly, for instance, words could not be exchanged between Barry's work and

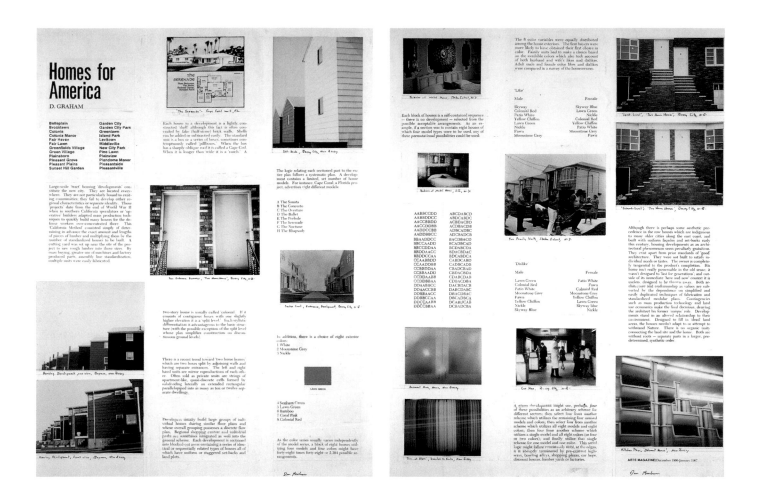

Dan Graham, *Homes for America*, photo-offset reproduction of 1966–67 layout for magazine article

Monk's without significant damage to both. In considering why not, we begin to learn about the different principles upon which each series has been composed. But it does not follow that the medium requires us to discriminate *in principle* against any particular type of projection, whether it be in the form of picture or of text, so long as it can be made to function as part of the individual sequence. It is to the distinctive character of this sequence that the spectator's critical attention is directed.

As to the problems of installation and environment, these appear *no more than* technical. Work such as Dibbets's *Land/Sea* may require precise alignment of its individual transparencies and its six projectors, but no significant problems of interpretation are at issue in the relationship between these separate components. An aesthetician bent on making trouble might ask where the

essential character of a given "work" is to be found. Is it in the original slide or slide sequence? In the insubstantial projected picture or sequence of pictures? In the all-too-substantial amalgam of projector, carousel, and electric lead? Or in some suitably orchestrated combination of all of these? But there is actually little incentive to pursue such questions into the higher reaches of theory. Unlike those contemporary enterprises within the Conceptual art movement whose artwork status was intentionally rendered problematic, most slide projections seem to invite the application of a ready common sense. It is evident enough that what each work requires is an appropriate and efficient set-up, slides in good condition, and a congenial environment for viewing. Some works demand enclosed spaces, and some do not. Once these requirements are satisfied, we can attend to the display and to any accompanying sound track, treating the apparatus as no more than a necessary means of delivery.

In accounting for the development of slide projections during a period of significant change in artistic culture as a whole, there is a further major factor to be taken into account. I referred earlier to the coincident development of abstraction and of collage and photomontage in the twentieth century's second decade. Marcel Duchamp's first "unassisted readymade" was also issued in the same decade. (We might conceive of the readymade—as Duchamp himself did—as a kind of extreme development of collage into three-dimensional construction, whereby the object selected from the world stands alone as the focus of critical attention.) It was of some critical relevance to the customary modes of the valuation of art that the printed materials of collage and the pictorial materials of photomontage were, in principle, repeatable, while the objects selected as readymades were typically common in type. The representative abstract painting, on the other hand, was a unique and handmade object. It can be argued, I think, that for some half a century abstract painting delayed exposure to the full implications of mechanical reproducibility and the readymade. It served to maintain the aura of unique, autographic things at the center of modern art's critical development, at least until the later 1960s.

But that was when the sands finally ran out—the point at which it seemed, for the first time, that for all the fascination attendant on its continuing development and theorization, abstract painting's moment of greatest achievement might already have passed. From then on, it simply ceased to be credible that abstraction could serve as an inexhaustible resource for art.[11] This was tantamount to a realization that modernism had no theoretical future, at least within the art world, because it was principally on the vitality of abstract painting and

sculpture in America that justifications for a mainstream high modernist art had been predicated.[12] In effect, authority drained away, as though overnight, from the arguments for a modernist mainstream. In so far as they recognized a specifically modern tradition at all, those in search of a new range of precedents now looked into the margins of half a century's art history, to which various adventures in photography, film, language, theater, and agitprop had largely been consigned. For some, what followed was that the modernist concept of autonomy was in need of critical revision; for others, the possibility of an artistic postmodernism lay in the development of hybrid forms.

Two distinct outcomes of the circumstances here outlined bore on the development of slide projection as an artistic medium. The first, following specifically from the exhaustion of abstract art, was that if a tradition of visual art were to be continued at all, there would need to be a reinvestment in pictures—not any longer in pictures as traditional, first-order, handmade things, as there could be no real interest or virtue in returning to the time of the premodern, but in pictures as photography now supplied them, including those pictures that photography transmitted from art. Through pictures, a world of reference and content could be secured for the practice of art, however technically various the compositions into which they might be assimilated. Slides, of course, offered a virtually infinite range of cheap pictures, easily accumulated. Their small size meant that they could be readily manipulated, while their transparency meant that they could be enlarged to the typical scale of paintings without the imposition of a lot of physical material.

This latter consideration was of some importance. A new generation of artists saw modernist theory, which privileged painting and sculpture, as perpetuating the long-standing implication of these media in concepts of high art. As a consequence, there was a virtual moratorium within the avant-garde on work that might be unproblematically categorized in terms of either painting or sculpture. Further, under the political divisions of the late 1960s and early 1970s, it was inevitable that the waning authority of modernist criticism should be associated not only with substantial works in painting and sculpture but also with an entire economic system in which such things were accorded cultural status and material value. This was the common ground on which such otherwise diverse enterprises as those of hard-line Conceptual artists, theatrical performers, and avant-garde photographers could possibly be brought together—the ground on which the critique of representation in art and culture converged with the disabused representation of an actual social state.

11. There could be few more telling witnesses on this matter than the author of the following: "by 1970, it appeared that the most promising branch of postwar American painting, the successors of Barnett Newman, the color-field abstractionists—had turned to ashes." See Frank Stella, *Working Space: The Charles Eliot Norton Lectures, 1983–84* (Cambridge, Mass.: Harvard University Press, 1986), 1.

12. That analysis of a modernist tendency in painting and sculpture had, coincidentally, acquired a new rigor and sophistication at the hands of Michael Fried served only to render the consequent hiatus all the more dramatic. It seemed all the clearer that a high price would be paid if one were to maintain either the macroscopic distinction that the resulting theory proposed between art and other modes of social practice or the microscopic focus it required on the bounded surface within the frame. On the one hand one was obliged to disqualify large areas of significant cultural activity, and on the other, to maintain an increasingly conservative investment in media that seemed simply to be running out of steam.

Louise Lawler, *Why Pictures Now*, 1981, gelatin silver print

13. "Some Remarks on So-Called 'Conceptual Art': Extracts from Unpublished Interviews with Robert Horvitz (1987) and Claude Gintz (1989)," in *L'art conceptuel: Une perspective*, exhibition catalogue (Paris: Musée d'art moderne de la ville de Paris, 1989), 92. It should be said that the market proved highly adaptable to the artists' supposed distrust of the object, that the artists concerned were for the most part only too ready to supply alternative tokens of ownership, and that Siegelaub himself played a leading part in establishing the terms of exchange.

14. For example, "We need objects?" (Art & Language [Terry Atkinson/Michael Baldwin], 1967); "I do not mind objects, but I do not care to make them. The object—by virtue of being a unique commodity—becomes something that might make it impossible for people to see the art for the forest" (Lawrence Weiner, 1969); "The world is full of objects, more or less interesting; I do not wish to add any more. I prefer, simply, to state the existence of things in terms of time and/or place" (Douglas Huebler, 1969).

A positive account of this oppositional frame of mind has been given by Seth Siegelaub, whose own entrepreneurial ingenuity was put at the service of the Conceptual art movement and its relatives in the late 1960s and early 1970s. He suggests that

there was an attitude of general distrust towards the object, seen as a necessary finalization of the art work, and consequently towards its physical existence and its market value. There was also the underlying desire and attempt to avoid this commercialization of artistic production, a resistance nourished, for the most part, by the historic context: the Vietnam war and subsequent questioning of the American way of life. This was certainly the most seriously sustained attempt to date to avoid the fatality of the art object as commodity.[13]

From the international avant-garde of that time there arose a distinct chorus of dissent—not only from work in painting and sculpture but also from the idea that making art necessarily entails making *things* at all.[14] Under these circumstances, the projected image offered one inestimable advantage: it provided a picture without depositing an object.

*SlideShow* contains a wide range of work, and not all of it can be explained in terms of the conditions of the late 1960s and early 1970s as here outlined. But early responses to those conditions clearly served to establish a certain tendency

in work with slide projections—a combination of intentional detachment from the cultural status quo with intangibility and physical impermanence of imagery—that is noticeable in subsequent significant work in the medium. Thus Krzysztof Wodiczko's *Real Estate Projection* plays economically on the extreme contrast between pictorial medium and pictorial content, between the insubstantiality of the one and the thoroughly material world that constitutes the other. Willie Doherty's *Same Difference* relies for its critical effect upon the mirrored and rhythmic reiteration of the same facial image and upon the changing pairs of predicates through which stereotypical readings of that image are catalogued and contrasted.

Such evidence suggests that the renewal of investment in pictures in the wake of abstract art goes hand in hand with a principled withdrawal from physical presence and self-importance, at least within those broad cultural tendencies to which the development of slide projection can generally be related. The first outcome of modernist abstraction's decline, then, directs us naturally to a second. This concerns the potential repeatability of works in the slide medium. In this respect, these works partake of a major shift in ideas associated with the wider Conceptual art movement of the later 1960s and early 1970s. At stake was the traditional assumption that the value of a work in the category of the visual arts is typically associated with its "autographic" character—that is, with its status as the sole product or authenticated edition from an individual authorial hand. The visual arts have conventionally been distinguished in this respect from the "allographic" arts of music and literature, where the work in question may be fully experienced in any performance or copy of the original text.[15]

In the American modernist art and theory of the 1950s and 1960s, a particular critical premium was placed on the one-to-one encounter between an attuned individual spectator and the unique, hand-painted surface of the abstract work. But with the decline of abstract art, the conclusion that that art had served to postpone became once again difficult to resist: that a time must come when no non-venal justification could be attached to the production of works of art as unique, autographic things. In the avant-garde practices of the later 1960s and 1970s, a number of attempts were made not only to break the connection between art and the autographic but also to conceive of a different kind of audience—one less clearly modeled on the leisured connoisseur and less evidently cut off from the normal occupations of everyday life. Works of art were issued in the form of instructions for actions to be performed, as announce-

15. "Let us speak of a work of art as *autographic* if and only if the distinction between original and forgery of it is significant; or better, if and only if even the most exact duplication of it does not thereby count as genuine." See Nelson Goodman, *Languages of Art* (Indianapolis: Hackett, 1976), 113, where the distinction between autographic and allographic types of art is discussed. (An allograph is a signature made on behalf of another.)

16. In 1969, the film *Land Art* was broadcast over nationwide German television. The enterprise of the filmmaker Gerry Schum, it lasted some forty-five minutes and consisted of works by seven artists—including Dibbets, Smithson, and Oppenheim—that had been made specifically for the medium of television. It was shown without commentary or explanation.

17. As once contingent and ephemeral enterprises acquire the market status of historic avant-garde works, value attaches to the combination of relative rarity and established authorship. In many cases the *only* necessarily unrepeatable element of the work of art as traded is now the literal autograph on a certificate of authenticity.

18. Theorization of the distinction can be traced back to Gotthold Ephraim Lessing. His *Laokoön, oder Über die Grenzen der Malerei und Poesie* was published in Berlin in 1766. Greenberg's *Towards a Newer Laocoon* was published in *Partisan Review* 7, no. 4 (1940) and referred back both to Lessing's work and to Irving Babbitt's *New Laokoön: An Essay on the Confusion of the Arts* (1910). Greenberg's essay associated the possibility of aesthetic quality with the preservation of distinctions among the arts, with medium-specificity, and, so far as painting was concerned, with abstraction.

19. Robert Smithson, "A Sedimentation of the Mind: Earth Projects," first published in *Artforum* (September 1968); edited reprint in *Art in Theory, 1900–2000: An Anthology of Changing Ideas*, ed. Charles Harrison and Paul Wood (Oxford: Blackwell, 2003), 880.

ments of actions that had been performed, as books in theoretically unlimited editions, in the form of broadcast television programs,[16] and so on.

A work composed of a projected slide or series of slides could, in principle, be issued in any quantity consistent with the maintenance of a specified quality in photographic reproduction. In fact, unlike negative film, color slide film produces a single image from each exposure. A slide sequence is ordinarily a sequence of unique images. It is possible, however, to make multiple exposures from the same generic subject, or to copy slides once processed, or both. The point is that none of the components of a slide work need necessarily be regarded as unique or precious. For all that an expanding market in the avant-garde art of the period subsequently encouraged other valuations of the enterprises concerned[17]—and for all that the slide installation has latterly been brought to a high level of complexity and sophistication, notably in the work of James Coleman—it was in part the sheer unpretentiousness and accessibility of the color-slide medium that made it attractive to those who first adopted it.

The distinction between the autographic and allographic arts is, of course, closely related to another distinction: that between the so-called arts of space, like painting and sculpture, and arts of time, like literature, music, and film. This categorical division had long been central to modernist theories concerning the integrity of the different arts[18] and was therefore equally vulnerable to assault in the later 1960s. This division-in-principle would be undermined by any work of visual art that necessarily unfolded over time, as a slide sequence must do. "For too long the artist has been estranged from his own 'time,'" Smithson wrote in 1968. "Critics, by focussing on the 'art object,' deprive the artist of any existence in the world of both mind and matter. The mental process of the artist which takes *place* in time is disowned, so that a commodity value can be maintained independent of the artist."[19] In the very different works of James Melchert and Ana Mendieta, the slide sequence preserves a sense of unfolding action on the part of the agents represented. It thus brings a distinct and more clearly pictorial formality to endeavors such as these (which would otherwise be classed as performance).

These examples demonstrate that slide projection offers a new kind of medium-specificity to enterprises within the now much expanded ambit of the visual arts. A particular feature of the slide sequence is that it allows a pictorial mode of artwork to extend over a period of time while preserving a measure of distinctness from the medium of film. Lothar Baumgarten's *I Like It Here Better*

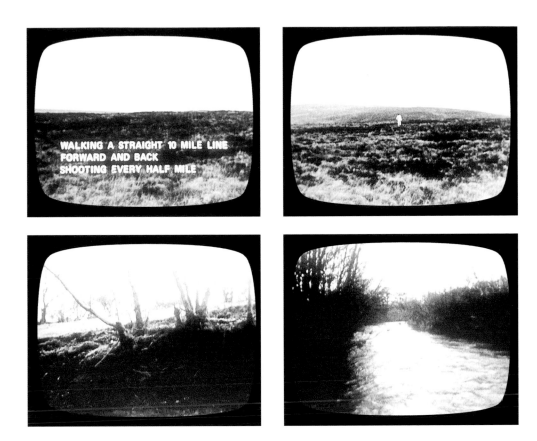

*Than In Westphalia (Da Gefällt's mir besser als in Westfalen) ELDORADO (Voltaire's
Candide)* may actually have led to a film, but it is of the essence of the original
work that its numerous images are both composed and experienced separately
and in succession, through all their deceptive changes of illumination, focus,
color, and detail. By the same token, *Projection 4 (P)*, the much later work of
Peter Fischli and David Weiss, depends for its effect upon the alternation
between two projected carousels of slides and upon the successively overlapping
images as light from each waxes and wanes in turn. It is a condition of the dis-
tinctiveness of its effect that it is *not* a film.

SlideShow offers the first focused and extensive survey of slide projection as
an artistic medium. It thus provides material for inquiry into problems of catego-
rization. For instance, should we regard slide projection as one medium, with a
significant common core but several different variations, or as many media, con-
nected only trivially by the use of a particular photographic device? The works by

Ceal Floyer, Louise Lawler, and Wodiczko consist of unchanging projections from the same small sets of slides. Other works, such as Barry's, are composed of continuously projected sequences that we can enter or exit at any point in the cycle. Baumgarten, on the other hand, requires that we start at the beginning and follow to the end of what is, in effect, a kind of narrative. Both Smithson's *Hotel Palenque* and Nan Goldin's *Ballad of Sexual Dependency* have integral sound tracks, though they are otherwise quite dissimilar. Are these all varying uses of the same medium, or are we really considering categorically different enterprises? If the former, does the medium naturally tend to the spectacular? Or is its normal effect to foster a certain skepticism regarding the dramatics of imagery? Can we define the medium in terms of a broad type of activity that it provides for its audience, or is its lack of prescriptiveness in this respect one of its characteristic features?

These are among the many questions that the selection of works in *SlideShow* may encourage us to ask. They will not necessarily yield single right answers. But it matters that we consider them if we are to make significant comparisons—and particularly if we are to discriminate to any effect among the works on display. And that the work of art offers itself up for the exercise of significant discrimination on the part of its audience is the one indispensable function by which it can be recognized as such.

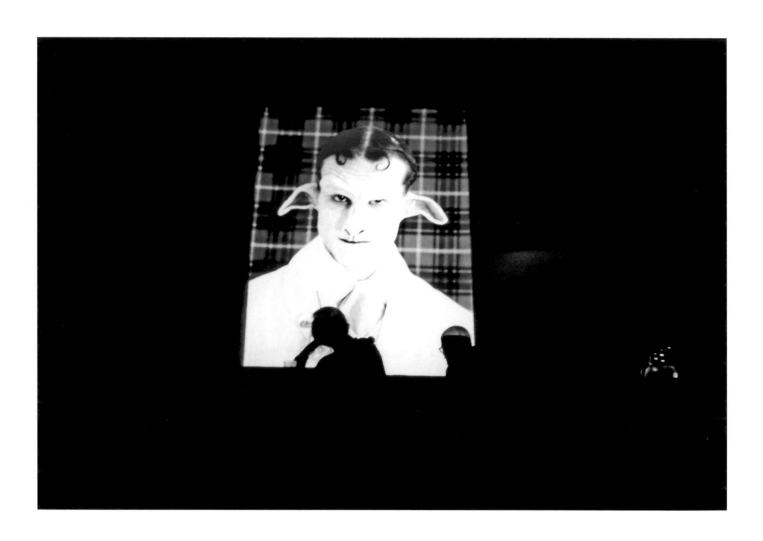

# NEXT SLIDE, PLEASE ...
## *Robert Storr*

Slides are the common coin of the art world. Borrowed from the realm of souvenir hunting—where they allowed travelers to collect and hoard their memories, and families to archive the major and minor events of their lives—they rapidly overtook black-and-white glossies and more costly photo transparencies to become the primary means by which images traveled from studio to gallery and curatorial offices, and from there to seminar rooms and lecture halls. Since their introduction in the late 1930s, color slides have engendered whole industries of manufacture, distribution, and storage.

As a result, it has become impossible to think of them without thinking simultaneously of plastic sleeves and cardboard or plastic boxes, of file drawers and projection trays (straight and circular), and of all the frustrations and the comedy of manners that come with these systems: the difficulty of slipping a slide into the almost invisible opening of a slide sheet made sticky by heat or by the degeneration of poor-quality PVC; the clatter of slide boxes and their tendency to dump their contents at the slightest opportunity; the frequent confusion about which side is front and which is back, which side up and which down, and which side in the end must face the lens and which the lamp, and in what vertical orientation (for which the cue is often a misplaced red dot); and the annoyance of stick-on labels that dry out in the projector's hot stare, not to mention the annoyance of trying to write in pen or marker within the slide's narrow margins and the frequency with which those smudged or blotted inscriptions read like the "Plan ahead" sign, posted in offices, that has the "d" falling out of line. Then there is the awkward business of loading circular trays only to find that the metal disc at the bottom is not aligned and that a slide has fallen through (at which point one turns the carousel over, forgetting that the sealing ring on the top is missing, so that all the remaining slides fall out); the predictable jamming of the slide-changing mechanism and the slow, unnerving business of trying to extract the slide with fat fingers or inadequate tweezers, which almost invariably results

in the slide's cardboard frame becoming irreparably bent so as to make future jamming inevitable; the time and concentration that goes into remounting and remasking the sprocketed film in glass and plastic frames with the certain knowledge that the glass will soon break and require replacement; the all-too-common burnout of slides that, left too long under the glare of the bulb as someone in a lecture hall digresses, begin to melt into wondrous patterns alternately suggesting microscopic cell mutations, Symbolist miasmas, Surrealist decalcomanias, and Jimi Hendrix–era light shows at the Fillmore; and the unpreventable fading of slides, which, depending on the film stock, means a graying or sepia-toned evening-out of once-brilliant full-spectrum colors. And of course there is the challenge of popping slides into envelopes and ringed binders and handing them over to implacable gallery assistants, to dedicated but overburdened curators at alternative-space slide banks, to lower-echelon museum people who promise to see that they get into the hands of someone in the upper echelon, or to art professors in the hiring halls of academia, where dozens of other candidates for this studio position or that assistant professorship lie in ambush armed with a savvy pomo pitch and bandoleers of slides. Then, too, there is the awkward business of having someone thrust a packet of slides at one after a short conversation at an opening as if he or she were passing off hot tips at the track or state secrets in the latest episode of *Alias;* the wary negotiations that surround borrowing slides from galleries to prepare lectures or exhibitions, along with the anxiety of wondering how soon and with what degree of indulgence that loan will be called in ("Dear X, I'm sorry, but we've mislaid the whole folder. Yes, I know it cost hundreds of dollars, but . . ."); and, finally, the social discomfort when slides are returned to their source with a note of comment, and the problems of having to write the note, usually with a combination of guilt and irritation, or of having to read the note, usually with a combination of dismay and resentment.

Still, the reason that slides are in such demand is simple. They are a convenient, nearly universal format in which things generally large, or at least of middling size, can be made small so as to be made large again. But as with all currencies, slides create multitiered patterns of exchange—that is to say, their own economics, sociology, and etiquette, an entire culture based on little more than a fragile 35 mm integument of light-sensitive cellulose laminated in a reinforced paper square.

That culture is about to reach its end. Nevertheless, this exhibition is a first. Never before has an American museum devoted an exhibition exclusively to slide-based art. So just as Kodak—the major domestic supplier of slides and slide equipment and a trendsetter in the industry worldwide—has made public its decision to curtail production, slides will be recognized as a medium in their own right. Once again, the avant-garde has been trumped by commerce: not, this time, by co-optation and meretricious imitation, the nemeses of so much stylistic novelty, but by obsolescence, a fate that is soon to catch up with film and video (although the outstanding irony remains that all these means of photomechanical reproduction were predicted to eclipse painting and drawing, which depend less on the macrodynamics of technology and fluctuations in market share). "Late capitalism" is full of unpleasant surprises for economic determinists and their aesthetic fellow travelers. This exhibition, then, has a commemorative rather than annunciatory aspect. It addresses the timely exploitation of a previously nonartistic means of reproduction and the delayed critical and public appreciation of the result. It's a matter of glancing at artistic innovation in a rearview mirror when passing signs made one think that its highest concentration still lay ahead. Instead of offering a retrospective of an artist or even a group of artists with a common aim, this show presents a retrospective of a way of seeing and its possibilities. Because its subject essentially belongs to the past, and because that past is largely circumscribed by the context of formalism (and the forces that contested formalism's teleological program while selectively placing its methodologies at the disposal of a broader understanding of what art could be, materially and experientially, and could concern itself with thematically), perhaps the most straightforward approach is to ask what qualities in a slide lend themselves to aesthetic use, and what opportunities for manipulation and expression those qualities afford. Or—to quote formalist scripture with mildly devilish intent—how might we define the humble slide's medium specificity?

Happenings, or what eventually became known as such when Allan Kaprow coined the term in 1959, were among the early instances of slides being used as an art form. Thinking back on *Theater Piece No. 1,* the multimedia performance collaboratively staged at Black Mountain College in 1952 by Merce Cunningham, John Cage, David Tudor, and Robert Rauschenberg, Carroll Williams recalled hand-painted slides projected onto a screen. Francine du Plessix Gray, who was also present that night, remembered films. Later, when Kaprow mounted his

Allan Kaprow, installation view of *18 Happenings in 6 Parts*, Reuben Gallery, New York, 1959

first Happenings, slides were projected onto plastic sheets already partially covered with abstract patterns, while lights with colored theatrical gels were cast on the same translucent surface. These facts, and the distinctions implicit in them, tell us several things. Like Happenings themselves, the slide-as-medium had hybrid origins, and painting provided some of its initially dominant but gradually more recessive traits. This precedent reminds us, though, that the overriding characteristics of the slide-as-medium are transparency and the capacity for projection, not anything exclusively photographic. For parallels, one can turn to the hand-painted or hand-drawn films of Stan Brakhage and other leading figures in avant-garde cinema in roughly the same transitional era—the late 1950s and early 1960s.

The slide-as-medium thus started out occupying a position informed by what it was *not* as much as by what it *was*. It was not necessarily a photograph, but it was based on photographic technology and was inevitably affected by the habits of photographic vision. It was not a painting as people were accustomed to experiencing paintings, especially in a period when gesture (as an index of the painter's body) predominated, because the slide obviously distorted gesture by enlargement. It did, however, exploit the hand's invention and the accidents of process in a manner similar to that of painting. Indeed, the slides in the Black Mountain event would seem in essence to have been miniatures of the painting on plastic sheets in Kaprow's *18 Happenings in 6 Parts,* with the advantage that they could wax and wane in size according to how they were shot up onto the wall. Moreover, in 1957, Michio Yoshihara—the son of Jiro Yoshihara, who had founded the Japanese Gutai group—used slides prepared with glue, ink, paint, and paint retardant for a performance. The images on the slides were not yet dry, and during the performance they moved almost like living organisms under a

microscope. Thus, thanks to slides, action painting of a whole new variety was born. (Notably, slides are not like colored stagelights: the framing of light by the mount is more cut-and-dried than even the most concentrated spot, and the "gestalt" of the slide is of something in one dimension that has been captured, isolated, and put on display in another, whereas the stage light isolates—or bathes—something actually there displaying itself in a "real" proportion to the viewer.)

Such points of comparison naturally condition our responses to the slide-as-medium. The Black Mountain piece may have incorporated both films and slides; there is no definitive account of that night. But the variance between Williams's recollection and that of du Plessix Gray indicates an essential difference between the two types of projected image: motion. Movies "move," but slides—setting the Gutai example aside as an exception—are static. This is both elementary and significant. The deciding issues, of course, are the sequencing of images and the number of frames per second that must be shown before the eye is fooled into believing that the flickering picture in front of it has a life of its own. Long-duration slide projection is problematic because of burnout or melt-down. A heavily qualified exception would be the work of Giovanni Anselmo, who uses a simple stencil dropped into a projector to train light that etches the word *Particolare* onto objects or surfaces, thereby employing a multipurpose (and to that extent general) term to indicate a "particular" thing. Normally, though, slides cannot just sit there on a wall to be examined at our leisure or ignored like a painting. Even the most rapid projection, using standard equipment, doesn't come close to the speed of movie reels feeding fractions of time and space to the illuminating bulb. This discrepancy constitutes artistic opportunity.

Accompanied by the clunky music of the projector's fan and its regulating mechanism, slides change no faster than the rate at which they can be manually inserted—or, automatically, within a range of two to eighteen seconds per slide. White noise thus fills the alternately bright or penumbral space while percussive sounds signal the disappearance of an old image and the appearance of a new one. To the extent that we are fixated on what we see when the light is on (and are lost in the afterimage that lingers in the dark interval), time expands and con-tracts; forgetfulness and suspenseful expectancies of various kinds compete; and all the while the metronome of the projector keeps objective, hypnotic count. Usually, though not always, the slide-as-medium combines auditory rhythm with visual cadencing. When other acoustic components play a part—recorded

the sand. The chromatic disparity among the slides—faded shots coming on the heels of relatively saturated ones—adds to the dynamism, as if we were zooming in and out on the scene from above while trying to refocus it. A cinematic version of this same event might capture the actual speeding up of the pair's rotation and their oscillation within the pictorial frame as weight and balance shift around the pivoting man. While conceivable in stop-action film, though, the sequence's herky-jerky quality and the spasmodic lurching of the figures tending toward spinout belong naturally to slides.

James Coleman's projection pieces take positive advantage of the same technology of elision, but his works, being explicitly theatrical (unlike Oppenheim's), are basically *tableaux vivants* superimposed on protracted fade-ins and fade-outs that accentuate the formality of his scenarios' psychological dynamics. Everyone represented consciously plays a role, a point reinforced in the viewers' minds by the staginess of the actors' gestures and the settings. Operating in the gap between still photography and film, Coleman underscores the fact that in both media, nothing is ever unmediated. Yet conventions of behavior are simultaneously codified and concealed by the conventions of seeing, which are based on a too-willing acceptance of what the camera records as natural or naturalistic. Here once again, though, the phantom of painting passes between our eyes and the screen, for in many respects, Coleman's images are constructed like academic figure studies, allowing for the enjoyment both of the affectations of the "poseurs" and of their evolving confrontation with one another. The success of this continuous substitution of static slides can be measured, in part, by contrasting it with Bill Viola's recent attempts at rendering old master paintings in extreme-slow-motion video. Viola's work strains the public's credulity. A viewer's ability to keep a straight face is directly correlated with an actor's ability to hold character. The more exaggerated the expression, the briefer its duration must be—or, conversely, the more frozen it must become. In theater, masks embody such states so that we may contemplate them past the time limit imposed on active mimicry. By technological means that situate the image at the perceptual limit of mobility and immobility, Viola's videos milk feeling from his players— and his audiences—by denying the aesthetic difference between essentialized emotion and the psychological flux of being. Coleman addresses the same problem more frankly by creating postmodern "masques," a genre of Renaissance entertainment in which the only thing to be taken for granted is artificiality. Slides aid him in this project by announcing their own artifice, while they show

James Coleman, still from
*Photograph*, 1998–99, projected
images with synchronized audio
narration

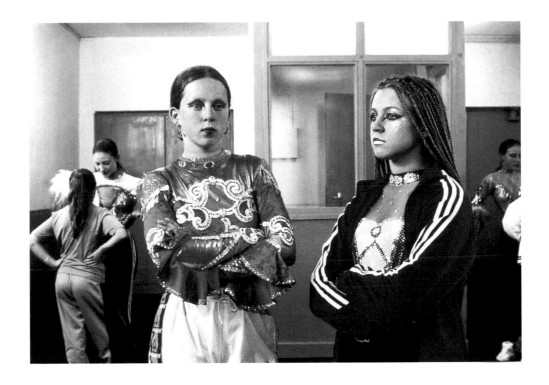

us all we can possibly absorb in the time allotted with a vividness painting struggles to match.

Lothar Baumgarten's *I Like It Here Better Than In Westphalia (Da Gefällt's mir besser als in Westfalen) ELDORADO (Voltaire's Candide)* is a partial exception to some of the things just said. In this dawn-to-dusk evocation of a primeval forest, the artist uses pictures taken and sound recorded in the woods and swamps along the Rhine to suggest the jungles of the Brazilian Mato Grosso. In so doing, he plays upon the audience's susceptibility to certain tropes of explorer literature, effectively displacing the viewer from one continent to another, from the known to the unknown, from civilization to wilderness, from culture to nature. The carefully managed ambiguities of his imagery come with periodic disclaimers. For example, the algae-covered water that resembles a vast lake traversed by currents, canoes, and caimans that part the carpet of green reveals itself, on closer inspection, to be the edge of a eutrophic stream. An empty bottle floats at the top of the frame, serving to establish the actual scale of the image. And from time to time, shots of anomalously artful objects—minimal sculptures, really—are spliced together with photographs of frogs, snakes, turtles,

mushrooms, and rocks on the forest floor or a bird flying above, just as the thunder of airplanes landing breaks up the crescendo of animal calls and the thrumming of insects. In short, Baumgarten creates a fiction to which he discreetly gives the lie. It's *all* culture, with the longing for a return to Eden being the abiding cultural fantasy upon which his sleight of hand depends. (*The Origin of the Night: Amazon Cosmos* reprises many of these ideas, but in film, adding poetic and anthropological references in textual format. To date, it is the artist's only work in that medium.) In retrospect, *I Like It Here Better Than In Westphalia* approaches cinema in the synchronized irregularity of the slides' exposure. Lightning flashes on and off, but the image of a still pond lasts five times longer; the view straight up to the fuselage of a landing aircraft continues as long as the engines can be heard nearing the spot where "we" stand and tapers off as they move beyond us. Despite its narrative arc and these temporal equivalents to film editing, though, the work is not really cinematic. Spare, almost intimate, it is more like perusing a giant photo album or *National Geographic* while a Walkman pipes the ambient din of the depicted locations directly into your ears. Or—more accurately—it is like reading or being read to while someone else turns the

Lothar Baumgarten, *Tetrahedra, Pigment Stacked,* 1968–69, still from *I Like It Here Better Than In Westphalia (Da Gefällt's mir besser als in Westfalen) ELDORADO (Voltaire's Candide),* 1968–76

pages. To that extent, Baumgarten's work taps into the memories of childhood adventure yarns as much as Claude Lévi-Strauss's *Tristes tropiques*. And in keeping with such early bookish reveries, the savoring of images here is a function of the measured flow of unmoving pictures—not the forced march from climax to climax that propels moving pictures set in the same exotic places.

In *Projection 4 (P)*, Fischli and Weiss conjure a magnified Eden by somewhat more complicated procedures. Their techniques involve the double exposure of single frames of film in the camera coupled with eight-second dissolves that fuse the already compound images on the slides as two alternating projectors superimpose them on the screen. The effect is a continuous metamorphic sequence: toadstools melt into flowers, luminous parasites into succulent fruit. Depth of field fluctuates, focus wavers, saturated colors emerge and sink back into radiant tints and shades; the contour definition is lost, found, and lost again; marvelous amalgams of organic matter hybridize before our eyes through lush photo-grafting. Equally beautiful growth and decay, composition and decomposition, form and formlessness are conflated (as they are in nature) by the magic-lantern microcosm in front of us, though jewel-like hues banish even the hint of fetid-

ness, baseness, and death. Digital morphing would easily achieve similar results, and this Swiss team belongs to a generation of artists for whom such technology was readily available. Their decision to eschew that option and employ cruder mechanics points once again to the perceptual as well as conceptual differences between seamless illusions and those that heighten visual awareness precisely by drawing attention to artifice rather than concealing it.

Artificial paradises that look like the antechambers to infernal regions were Jack Smith's favorite haunts. In his work, the refined South American exoticism of Baumgarten goes Yma Sumac, and Fischli and Weiss's exquisite confounding of shape and color veers into a *horror vacui* camp decor and Pop still life at once superb and unapologetically trashy. A cross between Edward Gorey and Kenneth Anger, *Boiled Lobster Color Slide Show* anticipates the exuberant grotesqueries of John Waters, Nan Goldin, Cindy Sherman, and many other contemporaries. The low-rent, hothouse register of Smith's drag universe has something innocent about it—so long as we can agree that true innocence is not ignorance of impurity, but a wonder at its many-splendored variety equal to the wonder commanded by all other deeply embedded and richly detailed aspects of "human nature," an embeddedness and richness for which the encrusted junk, body, and flower tableaux interspersed in the slide cycle function as emblems. *Boiled Lobster Color Slide Show* is the only more or less intact example of Smith's many such works. This slide performance features a master of ceremonies—Smith—as well as vaudeville titles, a chorus, and as much of a plot as is necessary to justify multiple costume changes, makeshift props, and over-the-top histrionics. It follows the hide-and-seek peregrinations of a plastic lobster toy through a botanical garden and a tenement. As a skit broken up into a combination of set pieces and candid "backstage" views, it is the homage that dress-up and amateur photography pay to cabaret and Z-grade thrillers. "Glitter and be gay," sang the heroine of Leonard Bernstein's heavily coded musical from the 1960s, *Candide*. Smith traveled light—and more cheaply than Bernstein—but the gaudy, outrageous basics of the artist's slide work glitter still, etching themselves in memory as vividly as his film masterpiece, *Flaming Creatures*. More's the pity that *Boiled Lobster Color Slide Show* is the only slide work of Smith's we really have.

If the works I have described calibrate the distance separating slides from films, then Marcel Broodthaers's *Bateau Tableau* marks that between slides and paintings. In the lecture hall, slides are the standard, often uncooperative surrogates for paintings. At the lowest level, they are mere evidence—and usually mis-

leading evidence at that, as the image on the screen is seldom the size of the work it purports to represent, and the camera reduces surface detail to a homogenous smoothness that even lies about the smoothest, most photographic of paintings. Nevertheless, in this pedagogic context, slides may approximate (or on rare occasions, actually become) an art form simply through sequencing. Sometimes this is the discovery of inspired academics, sometimes that of renegades from their ranks. Ad Reinhardt learned the craft at New York University's Institute of Fine Arts during his four years as a student there between 1946 and 1950. In 1958 (the year before Kaprow's breakthrough *18 Happenings in 6 Parts*), he transformed it into a radical critique of the anti-formalist cult of spontaneity when he presented his retroactively named *Non-Happening* at the Artist's Club, a forum for the Abstract Expressionists and an incubator of camp followers and rebels of the next generation. This event consisted of showing two thousand slides he had taken two years before while traveling around the world on a grant. The format he chose—suites of images that compared architectural details such as cornices, pitched roofs, half-timbered buildings, and gridded windows as well as structural aspects of paintings and sculptures, including crosses, twinned figures, or details such as hands, feet, and buttocks—anticipates by several years Sol LeWitt's similarly taxonomic photographs as well as other conceptually determined photographic indexes, such as those of Bernd and Hilla Becher and Gerhard Richter. (Reinhardt's format also presages Dieter Roth's massive slide archive of all the buildings in Reykjavík, Iceland.) Each of these projects has its own rationale and tone. Characteristically, Reinhardt's method was rigorous to the point of absurdity, and behind his effort stood a mixture of erudition, whimsy, polemical sharpness, and unshakable devotion to what he called "art-as-art"—that is, premium quality, straight up, no chaser (and no bar-talk).

Broodthaers's disciplined assault on aesthetic shibboleths and his fundamental ambivalence toward art itself have something in common, paradoxically, with those of Reinhardt, and *Bateau Tableau* plainly manifests them. The piece traffics in the same anachronistic romance of travel that Baumgarten's *I Like It Here Better Than In Westphalia* does: it animates the fantasy of ships on the bounding main as if they were outtakes from *Mutiny on the Bounty* or *Master and Commander*. (Given the current gendering of art critics, we would do well never to discount the complexity and lifelong survival of boyhood dreams.) But the poverty of the visual stimulus—a flea-market daub—puts us far from Baumgarten's atmospheric photographs. Broodthaers's piece has an almost forensic

quality, too, as if each picture taken had been made by a conservator intent on documenting the damage done to an old master seascape (except, once more, the example is hackwork, not something by Manet). But the narrative is constantly interrupted and the document is full of anomalies. Just when two back-to-back slides begin to read as a close-up of men on the deck after a long shot of the ship heaving, an image of the canvas's tattered edge reminds us that this is, after all, just a painting. And just when we think we know what we are looking at, a flipped image showing us a detail in reverse dislodges our sense of how the parts relate to the whole, as do dramatic changes in lighting that rake the surface one moment, bathe it in aura the next, and then bleach it out almost completely with glare. At some junctures, we might wonder if there are two paintings rather than one. The physical dimensions of the work's shallow illusion are also held up to scrutiny, rather as if a dermatologist were inspecting a patient with welts, lacerations, abrasions, and quite possibly some inherent corruption of the flesh. Thus the presumptive beauty of the subject and the bourgeois appeal of the painterly manner fall under the sardonic gaze of one of painting's most implacable morticians; the rituals of connoisseurship are reduced to travesty; and all along, the objectivity of the work is emphasized by pictures that are utterly disembodied— pure or, in this instance, impure light. This final step completes a chain of estranging transformations from reality to representation: not from matter to spirit, but from inauthentic art to the genuine though intangible article that evacuates the traditions faked by "the original" with which Broodthaers started. Along with them go the values of formalist criticism, with their emphasis on truth to materials and process and the integrity of the pictorial space. Echoing Broodthaers's echo of Magritte, one might simply say, "These slides are not a tableau"—and not a bateau, either.

Until now I have spoken of screens, but in fact, walls commonly form the "support" for slide art. Indeed, one can safely exclude the screen as one of the basic components of the slide-as-medium, though some artists do use it and at least one, Allen Ruppersberg, has taken the ordinary collapsible screen and deployed it sculpturally in installations that incorporate painted or printed shapes that replicate film or slide projection. In *Bateau Tableau*, however, it is significant that, framed or unframed, facing the viewer or on its side, the picture on the wall is insubstantial while the wall is actual. In *Location Project #4, Powerhouse Gallery*, James Melchert's delightfully deadpan take on minimal and process sculpture—or is it a respectful permutation of those genres into another

Ad Reinhardt, stills from *Chronology, a Non-Happening*, 1956–58

medium?—the picture on the floor depends for its effect on our forgetting that the floor we look down at in the image is below the one on which we stand. What counts is the shared orientation of viewers to verticality and horizontality as they are articulated by the ladders and the bodies that take positions in relation to them—not a *trompe-l'oeil coup de théâtre*. Were this a moving image, we would have the sensation of observing people in another room from on high. By contrast, the resolved geometries of the slides and their succession as so many solutions arrived at within the given format gently guide attention away from the performative "how" to the compositional "what" of each frame. This positioning implicates the viewer in a matrix that extends into the gallery space (unlike film, which assumes that we will wholly surrender to vision as we follow the action in a parallel realm).

Krzysztof Wodiczko's *Real Estate Projection* is predicated on *trompe l'oeil* effects, but his purpose is not spectacle: rather, he means to prompt viewers to see the social signs that confront them from all directions. He creates the illusion that we are standing in the corner of an upscale apartment—the chic vertical blinds are the giveaway—by projecting three windows onto the wall that are, in fact, the same window shot three times in different light, forming slightly different angles, and with different arrangements of the blinds. Wodiczko then leaves telltale clues to what is actually going on inside and outside the building. Through two of the windows, we see the demolition of a tenement, and on the sill of one sits a pair of binoculars and a real estate guide. This is gentrification from the vantage point of the buyer of a renovated dwelling, or perhaps that of a speculator planning his or her next move. The quasi-naturalist theatricality and didactic thrust of Wodiczko's "you are there" relocation from the gallery to the front lines of social conflict are obvious enough once you notice them—but noticing them is what the piece is all about.

Willie Doherty's installation, *Same Difference,* also makes a political issue of where the viewer stands. Using two projections aimed at opposing walls, Doherty presents two versions of the same image of a suspected terrorist. Only the adjectives printed over her not-quite-pretty face (with its not-quite-legible expression) distinguish one from the other. Each positive term is juxtaposed to a negative term—repulsive/exceptional, sickening/discreet, intuitive/damned—with the good-bad dichotomy alternating sides. The pace of the shifts is such that to read all the words, we constantly have to change our footing or turn our glance. We are thus caught in a cross fire of contradictory versions of the same

woman, who may be known to the viewer—she was as notorious in Ireland as Ulrike Meinhof was in Germany—or unknown, but still recognizable as one of two intersecting stereotypes, the criminal no one suspected or the idealist wrongly accused. Mirroring each other in an endless repetition of descriptions that cancel each other out, the words effectively create a redoubled *mise en abîme* of sexual and social typologies, with the viewer pinioned in the middle.

In other words, the piece makes explicit the way in which public discourse projects meaning onto images. Jonathan Monk's *One Moment in Time (Kitchen)* does the same for private life. Each of the eighty texts that appear in blocky white type against the lichen-green background is the artist's typed-out version of a picture found in his mother's kitchen (as relayed by his sister over the telephone). Some are verbal landscapes. Most of these are vague, one is inconceivable, and one can't be confirmed by the reader: "The Dominican Republic," "Mexican City," "London," "Los Angeles in the Snow," "Is that New York?" Some are figure studies with unstated emotional dynamics: "Mum and dad with Sally," "Dad with Uncle Johnny (The Jazz Days)." Some are portraits of the artist—"You in the South of France"—and portraits of the artist as an artist—"You as Vincent Van Gogh." All involve the filtering of identity first through pictures and then through language. All concern how one person represents that reality to another. And in the representational spaces separating each phase of that transmission (as well as the visual space between the viewer and the green wall with white letters), all hinge on psychological projection. We imagine what it is like to be here when we are there, what it is like to be with him or her or them when we are not, what it was like to be in that company when we never were, what it is like to be him or her or something else: "I Never Wanted To Be a Painter—I Wanted To Be a Tap Dancer." We imagine what words without images will project on the screen or wall at the back of the brain and register how those images (remembered, borrowed, or invented) send currents of ease, anxiety, and desire throughout the body.

Projection—the displacement of the self, of the inner states onto exterior circumstances—is the most basic psychological mechanism and the fundamental condition of looking at pictures in the dark. In cinemas, though, we sink into more or less comfortable seats when we do this and quickly lose track of who and where we are. Slide work may be interpreted in this way, too, but many of the works discussed here correlate the converging beams of light and mind with physical position, and they conjugate "looking" as a verb of action as well as

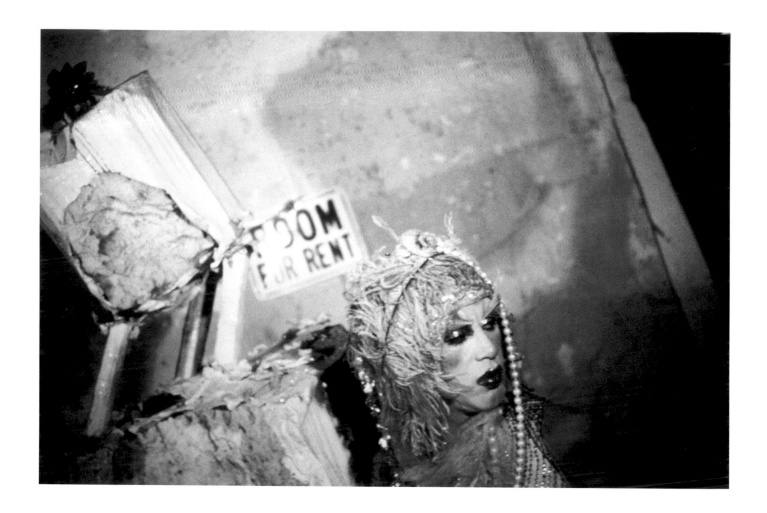

Jack Smith, still from
*Boiled Lobster Color Slide
Show,* 1970–88

reception. Meanwhile, temporal factors regulate this complex intersection of emotional and intellectual output and visual intake. The duration of a single image, its gradual fusion or abrupt contrast with another, the time that any cycle of images runs, and the number of times one experiences it contribute to the specific—I have ventured to say, medium-specific—way in which slides-as-art make meaning. The fallacy of all narrowly formalist thinking lies in supposing that any medium or method of making art can be isolated or reduced to a single quality. At the edge of any such aesthetic category are the edges of others. This is true of slides insofar as they do some of the things that paintings, films, and photographs do. The confusion is exacerbated when they are called to the aid of performative media and installation art such as that with which Gutai, Kaprow,

and their cohort, starting in the 1950s, slowly broke down prevailing formalist theory and practice. Still, the characteristics manifest in certain combinations of materials, procedures, and situations preserve important distinctions: What might be done—done best, or done at all—with this one or that? Ultimately, media have no will of their own, no a priori necessity to express themselves, but only limitations and potentials. Artists find them and mine them for art. For half a century, many saw sparkling squares of celluloid as patches of rich terrain on which virtually anyone with rudimentary equipment could stake a claim. Now industry and commerce have no further use for them. It remains to be seen what the judgment of artists will be.

*Transformation projector for lantern slides, 1870–1890s*
These finely decorated "cherry globe" units operated with long plates of painted glass that fed manually through the projector, creating the illusion of unfolding action. Ideal for domestic settings, these small projectors delivered amusing and at times devilish subject matter to intimate audiences.

*Biunial lantern slide projector, after 1916*
Lantern slide projectors came in various formats, including biunial and triunial devices for two and three lenses. With the biunials, the operator could mechanically dissolve separate pictures on the same screen by rotating their shutters; a third projector was added for special effects. Often an operator's skill was measured by how well he could achieve a seamless coordination of images—a difficult task that, when mastered, contributed to the magic and spectacle of lantern slide shows.

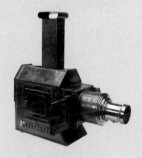

*Standard magic lantern slide projector, 1880s*
This type of projector was used in a variety of contexts, including an early version of the art history slide lecture. The chimney on the top of the projector released hot air generated by the oil burning inside. Stronger lamps produced brighter images, and more wicks required more ventilation. By the late nineteenth century, most slide projectors were meant for lantern slides made with a camera, replacing hand-painted images with photographic precision on a grand scale.

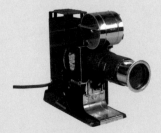

*Argus B Model slide projector, after 1937*
This small hand-feed projector was made for 35 mm slides or a continuous strip of film that could be run through the machine by rotating the film carrier. Powered by electricity and illuminated by a 100-watt incandescent bulb, this slide projector represented a new level of flexibility and power for a generation captivated by the novelty of color slides and home movies. The unit originally sold for $25.

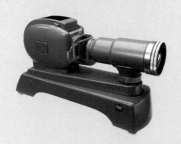

*Leitz Wetzlar slide projector, ca. 1951*
The post-WWII era witnessed the rise of slide shows of all varieties in private and public life. The streamlined and industrial appearance of this projector signaled its ascent in professional settings. Touted for its display of "ideal format" projections, which produced images with perfectly rectangular proportions, this type of projector allowed for the long throw of light over an auditorium filled with people. The side-to-side carrier (as opposed to the up-and-down gravitational system of later carousel models) also made slides easy to insert and extract.

*Kodak Supermatic 500 slide projector, 1961–64, and Instamatic camera, 1963–66*
The combined effect of the focus-free Instamatic camera and the hand-feed slide projector made taking and showing slides easy. Whereas older manual cameras resulted in frequent focus and lighting mistakes for average users, the Instamatic was designed for novices. Developed slides taken with this camera were then easily loaded into the modern-looking portable projection unit, which came with a stack loader (a spring to force slides into the projection chamber) and a single-slide feed accessible through an opening on the top. The number 500 refers to the wattage of the bulb.

*Nikomat slide projector, ca. 1965–70*
Several varieties of slide projectors available in the late 1960s created stiff competition in the marketplace. This projector, produced by Nikon, came with autofocus, remote control, and several convenient operational features, including a circular "rototray," straight trays, and a stack loader accessory. Users could choose which format best suited their needs, though amateurs and professionals alike eventually preferred the circular lateral trays—leading to the discontinuation of this adaptable product in the early 1970s.

*Kodak Ektagraphic slide projector, 2004*
Since 1961, when Kodak introduced its round carousel projectors, these units have dominated the slide industry. A zoom lens feature allows for a greater range of scale in the field of the projection. Given their operational consistency and their capacity to show incrementally timed images, these projectors and their derivatives (left) became the primary choice of artists using slides during the past forty years. The tray holds 80 slides—an improvement over older models that held 140, which jammed easily in their narrow slots.

# catalogue

Darsie Alexander     DA

Rhea Anastas     RA

Thom Collins     TC

David Little     DL

Molly Warnock     MW

maybe  partial

 end

# Robert Barry

*American, born 1936*

## Reflections, 1975

Twenty projected color slides and twenty Kodalith transparencies with text shown in alternation with blank slides

The Baltimore Museum of Art: Nathan L. and Suzanne F. Cohen Contemporary Art Fund; partial gift of Joanne Gold and Andrew Stern, Baltimore; and the Horace W. Goldsmith Foundation Fund

Robert Barry's *Reflections* consists of a single slide machine that projects a series of triptychs, or threesomes, that are repeated in a systematic fashion: Word. Blank. Image. Followed by another three: Word. Blank. Image. And so on, until a total of forty slides passes across projected light. Then the cycle begins again as the carousel wheezes in the dark. Visually, each of the three slide types retains a comforting, aesthetic uniformity, such as that often found in Minimalist works. The short words are legible, set in white type and centered against a black ground. The blank slides, which block the transmission of light, fill the gallery space with darkness. And the photographic images are consistently cropped within a circular black frame. The rigorous order, repetitions, and continuities of *Reflections* seem to signal some deeper logic embedded in its construction and prompt a desire to try to read and make sense of the triptychs as though they were brief scenes in the arc of a cinematic narrative.

Reading begins midstream for each viewer. You might not begin where I do; you might not end where I finish. Click. The word "maybe." Click. Darkness. Click. A photograph of a floor and window. Click. The word "partial." Click. Darkness. Click. A photograph of a snowstorm. Click. . . . Although the slide changes occur in equal intervals throughout, the work initiates a process of reading that has an uneven pace. At first, it is slow: words and images seem to wait patiently in the queue as the blank slides appear and disappear, leaving only a residue of vision, an afterimage, when they are gone. The blanks are also pauses in which we can contemplate the last word in the sequence and anticipate the next photograph. As the slides multiply and unfold, this reading process quickens, becoming more complex. If we are lost in the moment—spaced out—we may be thinking of the last image, or not thinking at all about what we have just seen. The three-slide sequence can morph into six, as the mind can alter the sequences. But by the fifth or sixth group of three, the strain of comprehension increases as each word and image builds upon another. As if we were reading

the credits after a film or television program, we try to fix in memory the word and image before they move off the frame and loop back through the carousel.

*Reflections* draws on the visual cues of silent films by using text, blackness, and the circular image to loosen rather than focus interpretation. It provides rich details but refuses to establish a continuous narrative. Its meanings expand and overlap and backtrack as each moment passes. The work encourages us to read—and yet not read. The words are simple ones: "further," "until," "before," "there," "gone," "perhaps," "anyway," "each," "approach." The images, too, are banal: a doorway, a wicker couch, and so on.

As Barry once put it, "nothing seems to me the most potent thing in the world,"[1] and this emphasis on the ostensibly empty signifier occupied him from the beginning of his career as an artist devoted to the potential of ideas to shape and reshape our conceptions of art. There is always something, even in nothing. In 1969, he created so-called immaterial works using nonindexical materials such as inert gas, electronic magnetic waves, radiation, and telepathy. In *Closed Gallery Piece,* visitors were greeted with an announcement: "For the duration of the exhibit, the gallery will be closed." For the duration of *Reflections,* blank slides mark and interrupt time, returning every other frame as the only repeated element in the sequence. Yet their pauses never truly occur; the gallery of the mind is never closed.   D L

1. Robert Barry, in a 1968 symposium; transcript
   published in *Six Years: The Dematerialization of
   the Art Object from 1966 to 1972,* ed. Lucy Lippard
   (Berkeley and Los Angeles: University of California
   Press, 1997), 40.

Installation view of *Reflections*

# Lothar Baumgarten

*German, born 1944*

## I Like It Here Better Than In Westphalia

(Da Gefällt's mir besser als in Westfalen) ELDORADO (Voltaire's Candide), 1968–76

One hundred eighty-seven projected color slides and audio CD

Courtesy the artist and Marian Goodman Gallery, New York

Lothar Baumgarten came to slide projection as a transparent medium that moved beyond the conventional parameters of the frame to express the mutability of time and experience. Like many of his peers favoring transient art forms, he resisted the production of commercial objects, preferring instead ephemeral works that expressed change thematically and materially. During the 1960s and 1970s, Baumgarten created a number of slide works linked to nature and perception. Through overlapping sequences of stills and dissolves, slides mirrored the cyclical themes of Baumgarten's art. Images of seemingly far-off places in the process of some subtle shift in their organic evolution take place in time, too, imprinting themselves on the viewer's memory and senses.

In the 1960s, Baumgarten began exploring the physical perimeters of his lived reality as the subject of his art, grounding his practice in environmental observation. Simple, everyday items crept into his art and became part of its photographically inspired vocabulary. The camera became a creative outlet that was also highly functional, allowing him to experiment with new subject matter in a mechanical, seemingly offhand way. Its portability gave him both freedom and access. The son of an anthropologist, Baumgarten collected ideas and images as if he were taking field notes—and with them, he constructed visual microcosms. Slides provided a specific kind of perceptual experience of these worlds by allowing their permutations to accrue gradually, in parceled-out segments. In 1968, Baumgarten began to photograph the outskirts of Düsseldorf and Cologne. The pictures he took culminated in a slide projection piece of 187 color images that unfolds over thirty-five minutes: *I Like It Here Better Than In Westphalia (Da Gefällt's mir besser als in Westfalen) ELDORADO (Voltaire's Candide)*. A symphonic mix of sound (added later) and image, the work presents a frame-by-frame encounter with wildlife, including birds, toads, and fluttering leaves. The site is ambiguous at first, presenting several intermingling possibilities: a jungle, perhaps, or an exotic sanctuary? As soon as one image appears, another

quickly replaces it, allowing but a few moments for lingering contemplation. Over time, however, the nature of this bucolic landscape reveals itself as the scenes fill with debris. By the end of the piece, the viewer catches the unmistakeable sound of a jet flying overhead. The habitat, it turns out, is a contaminated swamp where the most formidable presence is human.

In the many scenes of enigmatic items cast amid the debris and foliage, Baumgarten reveals his own agency as interventionist and manipulator. A feather, a banana peel, and a powdery mass of paint pigment show up in strange places at strange times. These small artifacts *could* be by-products of recent visitors, but they occur with enough frequency and deliberateness to deny the workings of chance. Baumgarten has called these his "manipulated realities," viewing them as a form of artistic production in which nature becomes a medium and canvas. As such, they situate the artist on the threshold of a growing phenomenon of subtle stagings—one that culminated in the 1990s with the suggestively altered landscapes of Gabriel Orozco. Baumgarten moved beyond observation to acknowledge the role of the artist as an instigator, driven by a desire to construct his own vision of the world. His art, then, commingles the found and the fabricated: "It's an image, but it's also a record of what I was doing at that time."   DA

Stills from *I Like It Here Better Than In Westphalia (Da Gefällt's mir besser als in Westfalen) ELDORADO (Voltaire's Candide)*

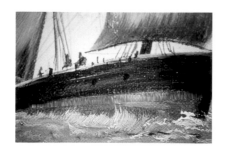

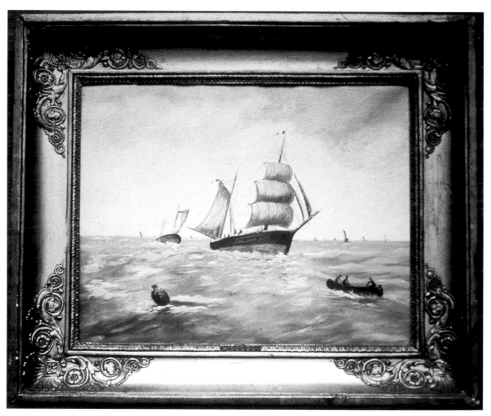

# Marcel Broodthaers

*Belgian, 1924–1976*

## Bateau Tableau, 1973

Eighty projected color slides

Collection of Pamela and Richard Kramlich

Marcel Broodthaers was a Conceptual artist whose work investigated the systems through which art gains credibility, accrues meaning, and finds distribution. He produced his work partly to resist those systems and partly to analyze them. In 1968, he established his own fictitious modern art museum and filled it with empty crates, postcards of nineteenth-century artworks, and a slide piece featuring old illustrations. With the "masters" of modern art notably absent and other works of questionable aesthetic merit given center stage, his museum called attention to the lofty yet dubious status of the art museum as a center of power in the art world. It symbolically lacked original objects and functioned largely as a repository of surrogate reproductions. Broodthaers treated these reproductions not simply as the by-products of his art but also as its subject.

Slides, too, played an integral role in how images from history and contemporary life were reproduced and incorporated in a larger network of artistic validation. Among other applications, slides were a staple of art history classes, in which students would learn the canon through large-scale images projected in the darkened classroom. Broodthaers consistently exploited projected slides in his installations and as stand-alone works that evoked these contexts. *Bateau Tableau* makes overt reference to the illustrated art history lecture with a probing visual analysis of a nineteenth-century painting, an amateur maritime scene. The slide series begins with a full view of the picturesque work in its gold frame, followed by increasingly fragmented scenes that highlight individual details to the point of pure abstraction. The representational style of the original, presented at the beginning of the cycle, becomes increasingly bold and gestural, as successive frames move in closer to the painting's surface. In addition to the obvious art-historical reference—implying a narrative that starts with figurative painting and ends with Abstract Expressionism—*Bateau Tableau* also exposes the transformative effect of the close-up, which is typically used to illuminate special features of a work's composition but in this case distorts them. Using a

work that he described as having been painted in the era just before the invention of cinematography,[1] Broodthaers produces a clash of aesthetics and histories in *Bateau Tableau*. On the one hand, the series depends on an outmoded form of genre painting. On the other, it promotes a specifically twentieth-century perspective produced by the monocular lens of the camera. Thus Broodthaers deliberately leaves open the possibility of perceiving multiple works inside one, for *Bateau Tableau* ultimately conflates painting, photography, and the projected image.

Other works were inspired by the same painting, known under its independent title of *Un tableau représentant le retour d'un bateau de pêche*. In addition to the slide piece, Broodthaers produced a book and two films. These versions added to the complicated issue of identifying the nexus of the art idea, which Broodthaers deliberately scattered among media. In addition to undermining hierarchies within his own practice, Broodthaers was known as something of a trickster with a clear sense of comic irony: "If you repeat 'tableau' and 'bateau' ten consecutive times, you will inevitably end up saying bateau instead of tableau and tableau instead of bateau, and by the sound of things you could hold forth on the last bateau as easily as on the last tableau."[2] Broodthaers thus insinuates a flip-flop in both visual and phonetic terms, with pictures and words alike providing variations on the same theme.     DA

1. Anna Hakkens, *Marcel Broodthaers: Projections*, exhibition catalogue (Eindhoven: Van Abbemuseum, 1994), 23.
2. Ibid., 25.

Installation view of *Bateau Tableau*

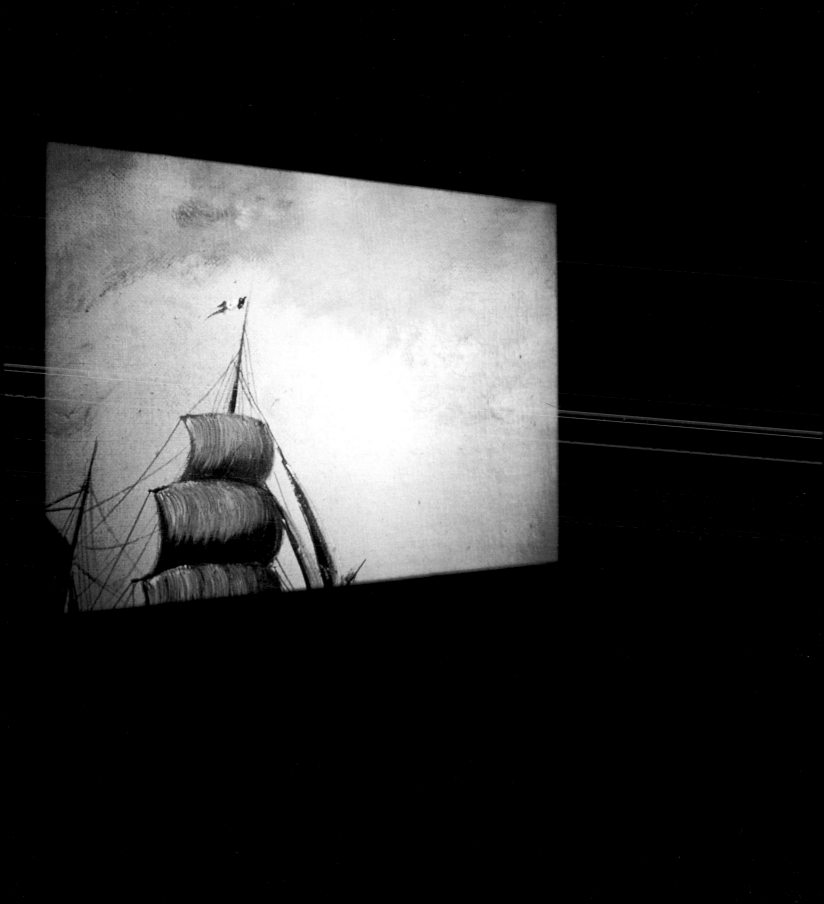

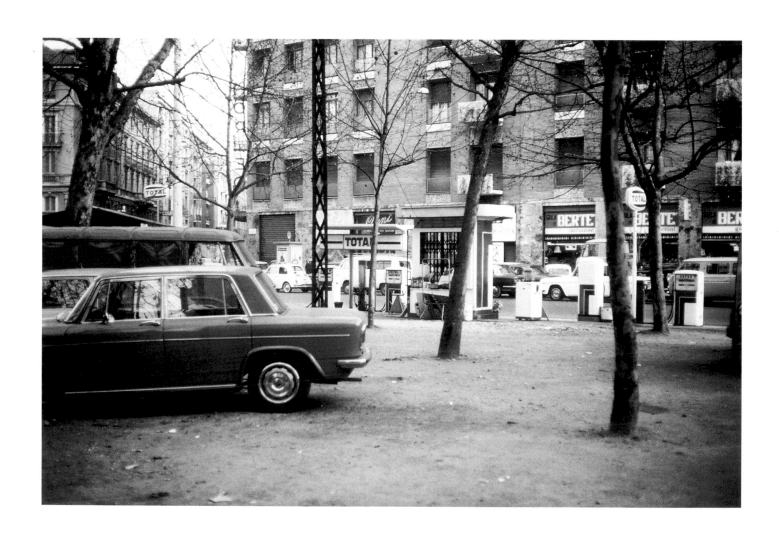

# James Coleman

*Irish, born 1941*

## Slide Piece, 1972

Projected images with
synchronized audio
narration

Courtesy the artist
and Marian Goodman
Gallery, New York

Slides are the foundational medium of James Coleman's work—the material transparency through which he projects complex issues of interpretation, representation, and spectatorship. *Slide Piece* is among his early experiments, and it foreshadows the principal themes of his subsequent works. The single image that provides the visual focal point is disarmingly simple: a car park in a European city. A few scraggly trees form a thin line intersecting the image, and gas pumps stand on the right at the edge of the curb. This picture lacks discernible action or obvious subject matter: is it the car in the foreground, or perhaps the barely visible pedestrian on the opposite sidewalk? In all matters of its physical and conceptual construction, it is a still. But as the artist notes in his title, it is also a "piece," supplying far more than an apparent transcription of everyday reality.

The fullness of *Slide Piece* is achieved through the sound track, a compilation of disparate reflections on the meaning and appearance of the image in question. In Coleman's work, voices provide an anchor *and* a guiding force, revealing how images are processed by individuals. Unlike the sort of sound track a movie-goer might hear, Coleman's voice-overs refuse to allow these interpretations to develop into a story line. In fact, spoken words often appear to counter, or at least deconstruct, the image on the screen. Divergent impressions emerge from details of the same parking lot, revealing how a photograph, in all its supposed objectivity, adapts easily to new captions and personal insights. But *Slide Piece* is not just a photograph—it is a projection, both of light and meaning.

Coleman creates opportunities for the viewer to shift perceptual focus many times in the course of one work. Shortly after *Slide Piece,* he made *Playback of Daydream* (1974), which deals in similarly spare terms with the theme of a single image taking on disparate characteristics. In this case, the projected image appears to change from a duck to a rabbit, bringing to mind childhood psychology tests designed to capture a subject's worldview through the interpretation of images. Coleman calls this phenomenon anamorphosis—a term that, for him,

describes the oscillating visual qualities and meanings embodied in a single work. In other Coleman works, this idea is remarkably well matched with the characteristics of the rotating slide tray, in which images are constantly being replaced and introduced, delivering an unending source of fugitive data to be processed. Sometimes these elements appear to follow one another with a predetermined logic, while other times they seem to collide, intentionally disrupting the pretense of progress. Combining the serial aspect of slides with the collage effects that accompany the use of multiple projectors, Coleman reminds his viewers that the slide projection is both a layering process and a loop that ends only to begin again.

The nuances of Coleman's work are equally apparent in his treatment of the subject matter of his images. Each picture seems to possess an array of representational modes beyond the strictly photographic. Coleman's later works, for example, feature heavily made-up performers dressed in bright costumes, alluding to the conventions of theater. Yet, as Rosalind Krauss has noted, they also bring to mind comic books and photo-novellas with their storyboard layouts and stilted poses. Coleman's interest in representation goes back to his youth, when he would draw museum masterpieces and photograph them, simultaneously incorporating the media of painting (the original), draftsmanship (the drawing), and photography (the reproduction). These experiments signaled an early preoccupation with artifice that would later blossom into highly staged scenarios filled with mysterious personae. *Slide Piece* was a crucial step along the way, establishing the centrality of projection as the physical, conceptual, and psychological foundation of his work.     DA

James Coleman, still from
*Photograph*, 1998–99, projected
images with synchronized audio
narration

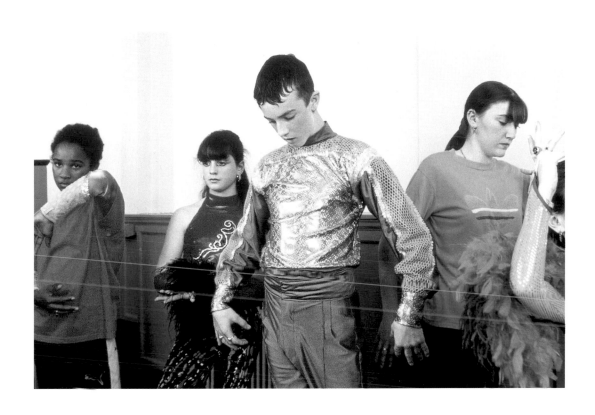

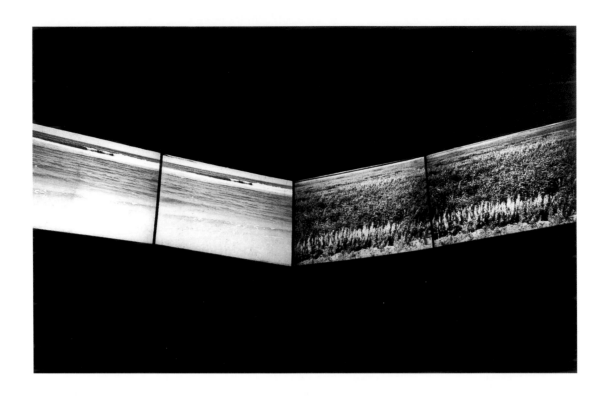

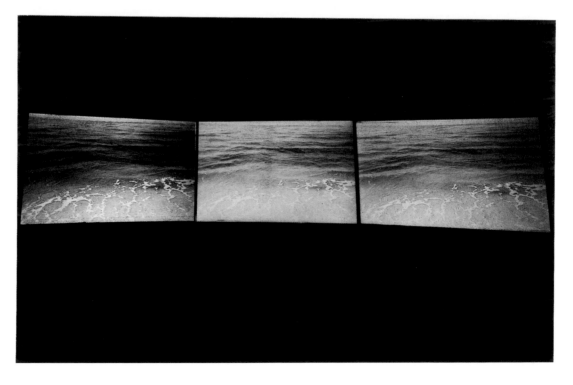

# Jan Dibbets

*Dutch, born 1941*

## Land/Sea, 1971

Three hundred sixty projected color slides

Courtesy the artist and Barbara Gladstone Gallery, New York

"A photograph does not produce an image. It registers gradations of light."[1] This observation by Jan Dibbets reduces photography to its barest elements, revealing in its brevity the artist's philosophical and technical stance on a medium he has worked with since the 1960s. As a student in the Netherlands, Dibbets knew nothing of photography's potential relevance for his work, but he taught himself the principles of taking pictures when a foray into outdoor performance required documentation. He began to study the camera obsessively, learning its inner workings—from the transcription of light to the effects of shutter speed. He found through this process a deeper understanding of how the artist, not the camera, produces the image.

Dibbets's work negotiates the separate and seemingly disparate interests of the artist as subjective voice and the camera as impersonal recorder. His images appear utterly direct, as if they were part of a larger systematic project that demanded the clear statement of facts. In one work, Dibbets captures the gradual movement of light across a window in discrete and ordered increments, signaling the passage of time. In another, he photographs head-on a trapezoid cut in the grass, which gives the appearance of a square standing up against an expanse of lawn when printed on light-sensitive paper. Here the camera simply observes in its own monocular, deliberate way. Dibbets, however, is exploiting— one might say manipulating—the information that enters the lens, knowing exactly how the camera will process and distort what it sees with "tyrannical indifference."

Working with slides allowed Dibbets to create new relationships among still images, coupling his interest in the photographic artifact with a desire to construct visual realities that could not exist in life. This combining of pictures was a form of collage that served to mark the progression of time (in serial suites) and extend the expanse of a given subject through the effects of panorama. In the early 1970s, Dibbets began to address one of the most traditional subjects of academic art—the horizon—by photographing the landscape in vertical and

Installation views of *Land/Sea* as shown at the Venice Biennale, 1972

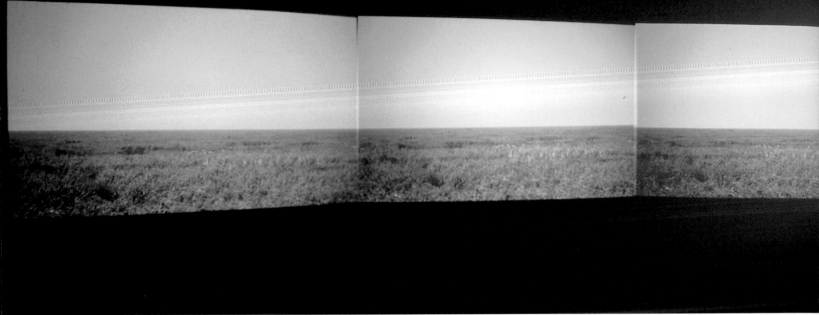

lateral increments and arranging the resultant images in clusters. Far from imitating the perfect and singular vanishing point of painting, however, these groupings bend and contort the landscape, making sea lines slope and flat meadows bow and wobble. Gravitational flux holds these works together. As curator Rudi Fuchs has observed, "When [Dibbets] remembers a painting by Piero della Francesca or Cézanne, it is not a heavy figure standing firmly on the ground, or two apples heavy in the bowl he thinks of, but something else: the slight suggestion of imbalance between the figures, the wavering of space, that almost unnoticeable irregularity of structure that introduces pictorial tension."[2] This tension is also perceptual, as the photograph immediately sparks recognition and the impulse to somehow believe what it depicts, however unstable it may be.

The slide piece *Land/Sea,* comprising six loaded slide carousels firing images simultaneously onto two intersecting walls, registers a long horizon dividing the shoreline from the ocean. Gradually, the line of the horizon moves up and down in accordance with the rotation of the separate slide carousels. At first, the vista seems plausible, as the viewer's imagination forms a vision of a wide-open sea banked by grassy meadows. But in fact, the slides are duplicates of one another, lined up in a carefully stitched unity that is self-contained and fictitious, a scenic invention of the artist. The optical trick is compounded by other minor distor-

Installation view of *Land/Sea*

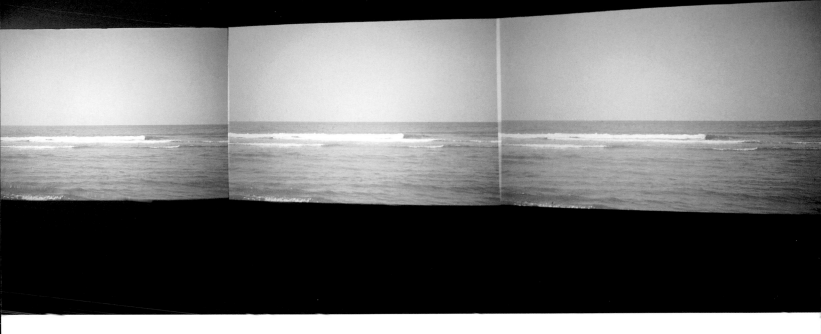

tions caused by the varying angles of the projectors and their suspension from the ceiling, which requires the viewer to look up rather than out to the horizon. Collectively, these attributes engage the observer's physical, visual, and perceptual faculties, making the process of seeing active and experiential.

Dibbets's return to the landscape as the source of fantastically aligned compositions underscores the subtle romanticism of his work, despite its obvious order. He sees nature as an active subject in the process of constant, imperceptible change, which only the camera can capture. Instead of crashing waves, the clatter of carousels clicking in rhythm fills the room. Space and sounds are reconstituted not as nature but as technology. The landscape formed in the *Land/Sea* projection spills out over the edges of its frame, spreading blue light across the walls.   DA

1. Jan Dibbets, from an unpublished transcript of a panel presentation on Conceptual photography, moderated by Scott Rothkopf, held at Harvard University on 9 April 2002. Other panelists included John Baldessari, Mel Bochner, and Ed Ruscha.

2. R. H. Fuchs, "The Eye Framed and Unframed," in *Jan Dibbets*, by Martin Friedman, M. M. M. Vos, and R. H. Fuchs, exhibition catalogue (Minneapolis: Walker Art Center, 1987), 59.

# Willie Doherty

*Irish, born 1959*

## Same Difference, 1990

Two static slide projections overlaid by moving slide sequences

Arts Council Collection, Hayward Gallery, London

Photographer and installation artist Willie Doherty lives and works in his native city of Derry, Northern Ireland. Doherty's artistic preoccupations have frequently centered on the complicated and mutually constitutive network of relationships that bind vision both to language and position in the formation of one's "point of view." Indeed, these long-standing concerns appeared in Doherty's first mature works, a series of black-and-white photo-text pieces he produced throughout the 1980s. They have also informed—and continue to inform—his more recent forays into video and slide work.

*Same Difference* was the first of three critically important slide installations Doherty produced in the early 1990s.[1] The work turns upon a "portrait" of the suspected IRA terrorist Donna Maguire, whose face Doherty photographed from a television news broadcast announcing her arrest by Dutch authorities. This black-and-white image is projected onto two diagonally opposite corner walls in a darkened room. Maguire is shown in a tightly cropped, frontal shot: her face fills almost the whole of the projected fields, which are themselves scaled to the size of the standing human form. The individual pixels of the televised source are clearly visible, and each image is further mediated by one of two very different sequences of words or "captions" cast by a second set of projectors. According to one series—culled, for the most part, from the Irish antinationalist popular press—Maguire is a "MURDERER," "PITILESS" and "WILD." In the pro-Republican language of the other series, she is a "VOLUNTEER," "LOYAL" and "WILLING." As the carousels advance, the projected labels on the two otherwise identical photographs clash, switch sides, and occasionally coincide.

Doherty and his commentators have repeatedly drawn attention to the particular historical and political conditions attending and to some extent catalyzing this work's initial appearance. Foremost among these factors was the media broadcast ban imposed by the British government in 1988 as a response to "terrorist" propaganda. This measure criminalized television and radio coverage of

Sinn Féin (the Irish nationalist party) and other proscribed organizations, attempting to silence the opposition views with which these groups were identified. What resulted was widespread "linguistic paralysis"—a condition in which, to quote the artist, "the only language left is a series of clichés about Irish psychopaths committing crimes without any apparent reason."[2] The political nature of the conflict was thereby repressed, as were the complicated and often intensely conflicted motivations of its human agents.

By juxtaposing two series of terms representing two starkly opposed descriptive regimes, *Same Difference* both tropes and resists a dualistic vision of the world in which a figure such as Donna Maguire could only be seen in black and white. With her enigmatic expression and smoky lids, Maguire confronts the beholder in the ambiguous moral guise of a modern-day Mona Lisa. Each of the captions may appear as a defensive gesture against her haunting, equivocal gaze, an attempt to put a name to her character—to pin her down—once and for all. That the different sequences claim this face for very different narratives is precisely the point. Caught between two mutually exclusive readings of the "same" face, one becomes conscious of the labels' power to elicit and condition particular perceptions: cast as a murderer, Maguire bears a shady smirk, but seen as a volunteer, her look is one of serene conviction. The steady click of the carousels punctuates these projections, forcing the viewer time and time again to reevaluate the precise terms of her relationship to and investment in a photographic image that is anything but transparent.

How one reads this face will be largely dependent on where one stands. As the viewer of *Same Difference* quickly discovers, to confront either screen head-on is to turn one's back on the other. At the same time, because the installation uses different projectors to cast images and text, respectively, the viewer can block one "layer" of the projection without necessarily affecting the other. One could, for example, stop the march of captions across one or both of the faces. Yet because the installation turns upon a diagonal axis, there is a space at the heart of the work where one can stand and see both images without interrupting either. To stand in an oblique relation to both is to grasp them dialectically, critically, as but two sides—two faces—of the same coin.   MW

Stills from *Same Difference*

1. Doherty also produced a slide installation in 1980, while still a student at the Ulster Polytechnic in Belfast.

2. Willie Doherty as quoted in Joel Linehan, "Willie Doherty: The Press Invented a Fable . . . ," *Third Text* 48 (Autumn 1999): 110.

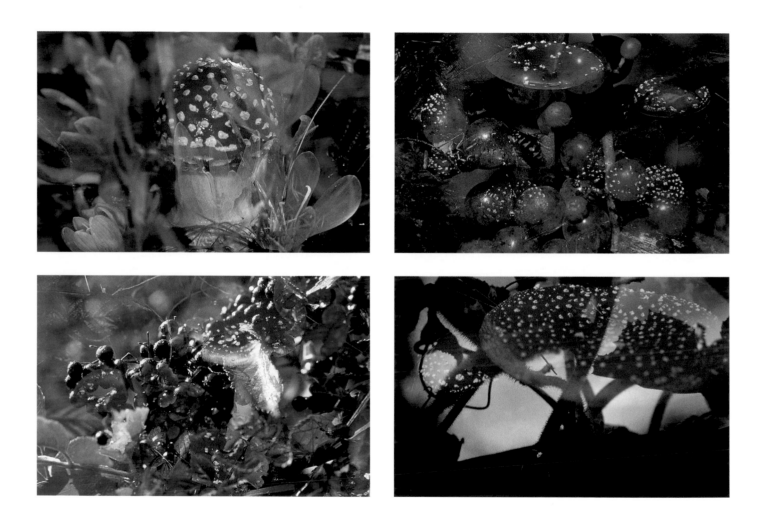

# Peter Fischli and David Weiss

*Swiss, born 1952 and 1946*

## Projection 4 (P), 1997

One hundred sixty-two projected color slides, two projectors, one dissolve unit, wooden pedestal

Philadelphia Museum of Art: Gift (by exchange) of Mr. and Mrs. R. Sturgis Ingersoll, 1999

Since first collaborating in 1979, Swiss artists Peter Fischli and David Weiss have taken on roles as renegade researchers for an imaginary addendum to Denis Diderot and Jean Le Rond d'Alembert's famous *Encyclopédie* (1751–65), an Enlightenment project that attempted to encapsulate human knowledge in seventeen volumes of text and eleven of illustrations. This time, the objects of analysis are set in the visual tempest of the twentieth and twenty-first centuries. Whether playing with sausages and kitchen items in their studio, hanging out in airports, traveling across the globe to visit famous tourist sites, or simply walking in nature, the artists take pictures of things, ordinary and extraordinary things in the world. They are collectors and producers of a culture that presents endless subjects for those with such desires. The problem for viewers is what to do with the results: the sheer quantity of Fischli and Weiss's often compositionally plain, unremarkable pictures of the world makes the task of organizing them into sensible taxonomies appear futile. Neither the quantity nor the themes yield understanding.

This fascination with collecting and documenting modern experience is evident in *Projection 4 (P)*. Fischli and Weiss operate as botanists, photographing a variety of flowers, mushrooms, gardens, and other plant types. Taken as a series of double exposures, the slides are anything but ordinary and understated. They possess an alluring and repulsive beauty that counters the apparent playfulness of the artists' earlier work. In fact, the notion of nature as idyllic quickly erodes in the presence of these huge, hyped-up images. Gigantic mushrooms dissolve and flow into (and are superimposed onto) one another, creating an amorphous blend of psychedelic color. The translucency of the slide images only adds to the confusing morass of curvilinear forms that never quite reach a comfortable zone of complete abstraction. Each plant form represented is never whole or autonomous; even if a viewer tries to freeze one for a moment, it quickly becomes something else.

The overblown scale and the microscopic obsession with nature apparent in *Projection 4 (P)* prompt comparisons with precedents in abstract painting, particularly Arshile Gorky's *Pirate* and *Garden of Sochi* series, which were based on close-up drawings of flowers and other natural plant forms. Gorky depicts natural plant life as forms that float within discrete easel spaces with white backgrounds. Viewers can always find points of relief in these illusionistic environments that separate the picture from the frame. Fischli and Weiss's changing slides, however, cover every square inch of the glowing, rectangular image frame with detailed color and texture, leaving only darkness beyond its parameters. Although the artists permit curators to alter the work's size according to spatial considerations, most installations eclipse even the most monumental works of the Abstract Expressionists, accentuating the spectacular effects of photographic magnification on painting and even nature.

It has often been remarked that photography reveals what is unseen to the human eye through the camera's technical ability to focus, stop a fragment of time, and enlarge a moment. Photographs provide detailed evidence that confirms knowledge—a horse galloping, a bullet at high speed, and so on. But Fischli and Weiss's slides of nature distort details of the real, pushing received knowledge about natural phenomena to new extremes. *Projection 4 (P)* presents mutant vegetables and plant forms without originals. The dissolving images suggest a decay of the real and eliminate any sense of distance from which a viewer might comprehend them. Time, too, is altered. The mushrooms exist in a timeless world, one in which nature does not grow and progress. Instead, this strange nature mutates over and over again, without seasons and without end.     DL

Installation view of *Peter Fischli/David Weiss*, exhibition at Matthew Marks Gallery, New York, 1999

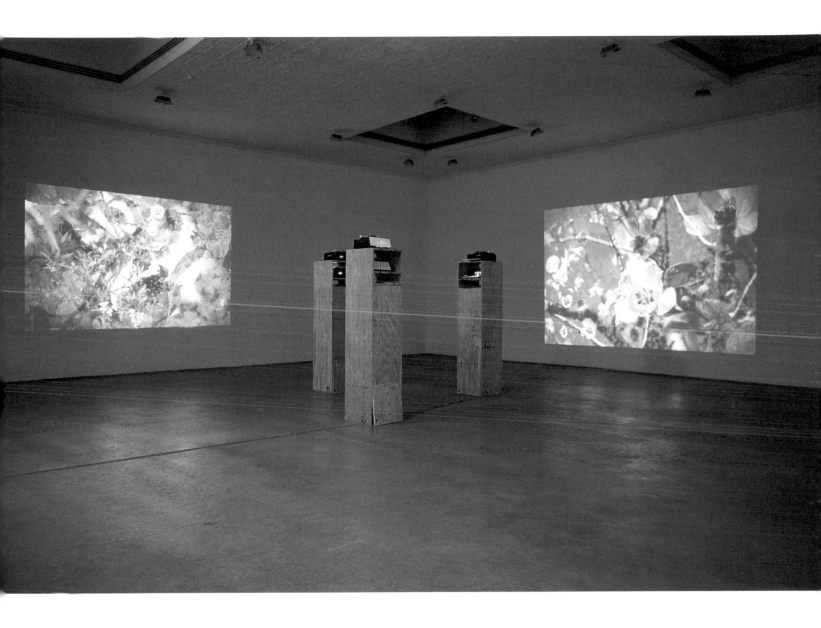

# Ceal Floyer

*British, born 1968*

## Auto Focus, 2002

Light projection through
slide projector

Courtesy the artist and
Lisson Gallery, London

The technology of slide projection—as a mediator of images, one that speaks in
a familiar yet outmoded language—is the basis of Ceal Floyer's *Auto Focus*.
Drawing upon a tradition of readymades initiated by Duchamp, Floyer extracts
the slide projector from the world of technology and vernacular culture and
places it in a central object-position amid spare installations. Her works stand at
a crossroads both in their art-historical reference points and their appropriation
of a soon-to-be-obsolete technology. The works "work," in part, because they
strike familiar chords in viewers' memories. But at what point will those associ-
ations disappear?

This question subtly informs much of Floyer's work, which hinges on things
fading, moving in and out of focus, and creating illusions on the walls. Many
pieces are so pared down as to nearly escape notice. In *Door* (1995), for example,
a concentrated beam creates the perceptual illusion of light filtering in from
another room. The work gently disrupts the spatial continuity of the environ-
ment by introducing flat, artificial light in place of natural illumination, render-
ing visible a small crack beneath a door. In a similarly minimal projection, a nail
is formed by a projected image roughly the size of an 8½ × 11 inch piece of paper.
Were it not for the physical presence of the projector, these understated gestures
could very well blend to the point of near invisibility. The projector, however, acts
as a signpost: it declares that there is something to be seen and points with its
beam to often-ignored places.

The stripped-down mechanics of projection in Floyer's work direct attention
toward the technology in a way that evokes the structuralist tendencies of film-
making during the 1960s and 1970s. In *Auto Focus*, she removes the slide from
the carousel, forcing the machine to operate without an image source. The
results produce a strange experience of beauty and futility. In an attempt to grab
an image that is not there, and thus render it in perfect focus, the lens shifts in
and out, forming a moving halo of white light on the wall.

Floyer's work calls upon the viewer's capacity to switch frames of reference—to hear images and to see sound. She takes what is most familiar about an object and inverts its seemingly most fundamental qualities, "like mentioning the obvious but in a different voice."[1] This strategy is not simply a perceptual trick. Floyer asks viewers to think in new terms about how their sensory systems channel seemingly familiar data. By applying commonplace perceptual instruments, such as slide projection, she reveals how technology has established habits in our viewing experience—habits that her work quietly disrupts.    DA

1. Jonathan Watkins and Ceal Floyer, "Have Trojan Horse, Will Travel," in *Ceal Floyer,* by Jonathan Watkins (Birmingham, U.K.: IKON Gallery, 2001), 7.

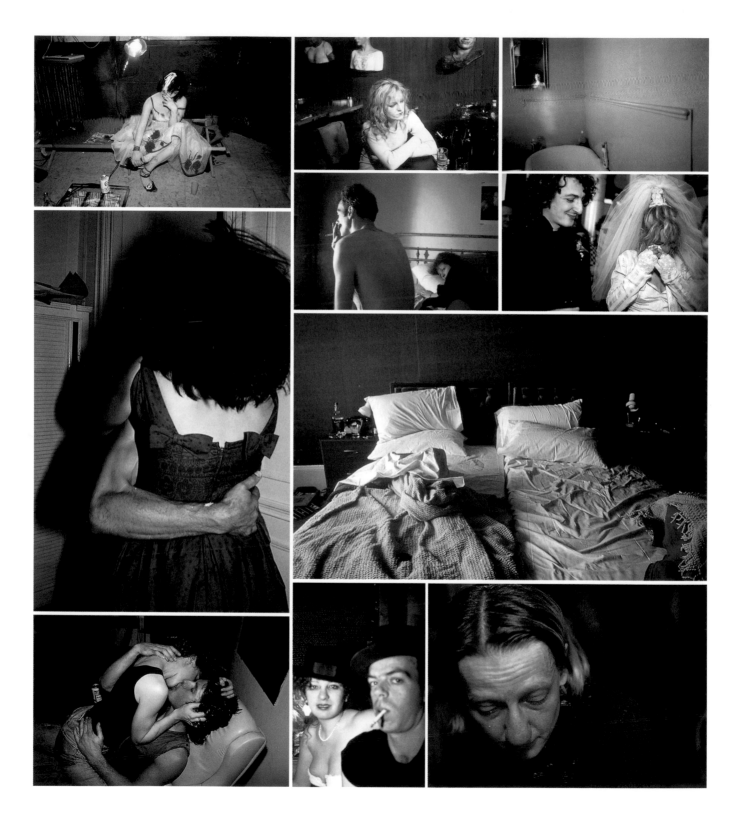

# Nan Goldin

*American, born 1953*

## The Ballad of Sexual Dependency, 1979–96

Nine-carousel projection with approximately seven hundred color slides, audiotape, computer disk, and titles

Whitney Museum of American Art, New York: Purchase with funds from The Charles Edelhard Foundation, the Mrs. Percy Uris Bequest, the Painting and Sculpture Committee, and the Photography Committee

From *The Ballad of Sexual Dependency,* (left to right) *Trixie on the cot, New York City,* 1979; *Cookie at Tin Pan Alley, New York City,* 1983; *Self-portrait in blue bathroom, London,* 1980; *The hug, New York City,* 1980; *Nan and Brian in bed, New York City,* 1983; *Cookie and Vittorio's wedding, New York City,* 1986; *Empty beds, Boston,* 1979; *Risé and Monty kissing, New York City,* 1988; *Self-portrait with Brian in hats, New York City,* 1983; *Suzanne crying, New York City,* 1985

Nan Goldin's *Ballad of Sexual Dependency* is like a family slide show with an open-ended story line. Formulated in the 1980s, when Goldin was living on the Lower East Side of New York, the work chronicles her personal relationships in images normally suppressed by the happy-moment formula of the snapshot family narrative. Goldin took her camera with her everywhere, photographing people she knew well but was not related to, drawing out their love, anguish, and vulnerability. She was not trying to create an objective record; rather, she wanted to understand what goes on between couples beneath the surface, out of public view. She took photographs where the nuances of human interaction were the most palpable and open—bedrooms, baths, clubs, and lounges. Occasionally she showed people having sex, but more often her images revealed the emotional side of intimacy. Among the first slides in *The Ballad* is a picture of the artist's parents at a restaurant. They look neither at each other nor at the photographer. It's an awkward moment that may have been fleeting, but it is what Goldin saw; it was her impression, locked into permanence by the camera.

Goldin photographed to consolidate her memories. *The Ballad* is an accumulation of past moments gathered together that says something about the people in them and how they lived. Goldin does not so much arrest time as locate it in specific faces and sites. As a teenager, she lost an older sister to suicide. The trauma of this experience intensified her desire to fill in the gaps of her past. At eighteen—the same age as the older sister when she died—Goldin started to take pictures. The process helped ameliorate her loss while giving her the freedom to explore her surroundings and relationships. While in Boston as an art student in the late 1970s, Goldin started to think more seriously about photography. Like many of her peers seeking to advance a career in art, she moved to New York in 1978. The next year, she performed a slide work at Frank Zappa's birthday party at Mudd Club, holding the projector in one hand and loading slides in the other. The slide shows were a way of making her images and life public, turning them into social events and performance pieces. She went on to do shows at the

Rock Lounge, OP Screening Room, and Artists Space. *The Times Square Show,* organized by the artists' group Collaborative Projects in 1980, was a turning point. It led to the formulation of *The Ballad* as a work. Collecting and ordering her images into loose sections, Goldin began constructing a story: happy couples; gender roles; violent, lonely, and vulnerable men; bars, drinking, and drugs; and back, eventually, to couples, empty beds, and graves. The music gave the work a permanent narrative voice while infusing the pictures with a rock-lyric subtext that heightened their drama and emotional resonance.

Over time, a number of Goldin's subjects died of AIDS and old relationships simmered. Fewer changes were made to the work as she directed her attention to new projects and successes. The publication of *The Ballad* book in 1986—and its formal realization as a prerecorded slide show the previous year—marked the end of an era. Goldin was advancing in her career, moving further from the reality of her personal *Ballad*.

Goldin once stated that "Stories can be rewritten, memory can't. If each picture is a story, then the accumulation of these pictures comes closer to the experience of memory, a story without end."[1] *The Ballad* is both a layering of stories and a structuring of memory. Organized around vignettes of particular people and relationships, it solidifies time, summing up feelings and experiences. Its themes of tragedy and desire are timeless, even if some of its actual subjects were not.     DA

1. Nan Goldin, *The Ballad of Sexual Dependency,* ed. Marvin Heiferman, Mark Holborn, and Suzanne Fletcher (New York: Aperture Foundation, 1986), 6.

*Self-portrait in blue bathroom, London,* 1980, still from *The Ballad of Sexual Dependency*

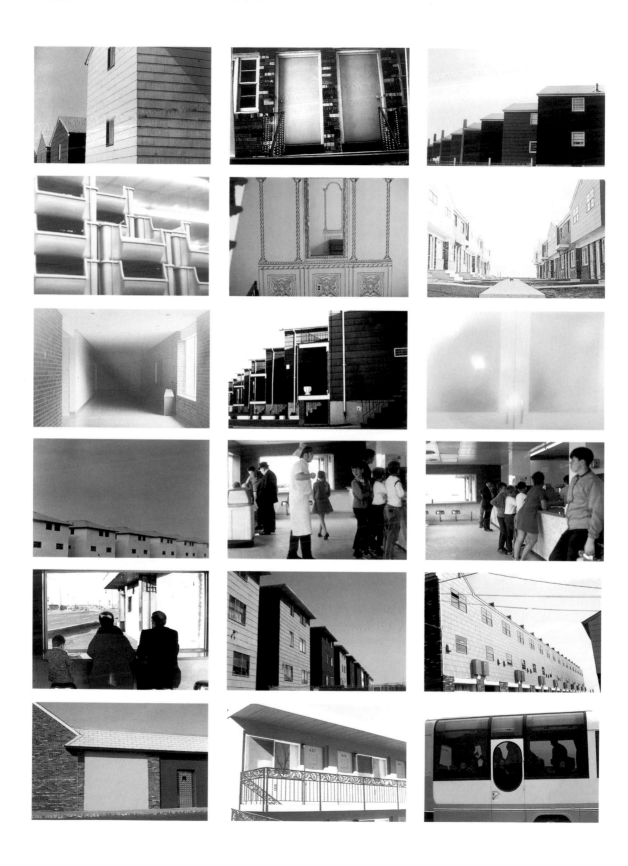

# Dan Graham
*American, born 1942*

## Homes for America, 1966–67

Twenty-one projected color slides

Courtesy the artist and Marian Goodman Gallery, New York

Dan Graham began the work now known as *Homes for America* in the summer of 1965. This photographic series recorded standardized tract-housing developments in such places as Bayonne, Trenton, and Jersey City, New Jersey. Graham depicts the mass-produced homes—arrayed in tight rows or literally attached—in broad, abstract strokes with the simple built-in perspective and cropping of a point-and-shoot Instamatic camera. Covered in aluminum siding or brick facing, the housing banks form low horizontal plinths or tall receding walls in his photographs, which often create shallow enclosures of space within the parallel edges of their frames. Graham carves large solids from the exteriors of the houses, and he arranges the visible details and fixtures—always the same factory-made windows, doors, steps, railings, gutters, or vents—in pairs or in sequence, perforating the units and the pictorial space of the images. In interior views, reflective surfaces (picture windows, mirrors, or glass doors) often "look back" at the camera, short-circuiting any illusion of pictorial depth. In still other photographs, diners queue up inside a fast-food restaurant, or pink bins stand stacked against the ceiling tiles and fluorescent lights of a discount store.

The artist described these peripheral spaces in an article in *Arts Magazine* in late 1966: "This serial logic might follow consistently until, at the edges, it is abruptly terminated by pre-existent highways, bowling alleys, shopping plazas, car hops, discount houses, lumber yards or factories."[1] His use of the word "serial" proved to be significant not only to the subject of *Homes for America* but also to its structures of presentation and reception. Graham first exhibited these images, originally entitled *Project Transparencies,* as a series of slides for projection. Three exhibitions of the slides were held in New York in 1966–67: twice in group exhibitions and once in a private screening in Robert Smithson's and Nancy Holt's downtown Manhattan loft.[2] In the same short time, Graham entitled his article "Homes for America: Early 20th-Century Possessable House to the Quasi-Discrete Cell of '66." This piece of criticism explored the same subject as his slide series and mixed journalistic writing with quotations, collaged text, and a repro-

duction from a real estate sales brochure. Confusingly, Graham's photographs were cut from the article before publication and would not appear alongside the author's text until his own originally conceived layouts were published in catalogues, journals, and art magazines starting in 1969.[3] Single images from the series frequently appeared in experimental-art magazine criticism produced by fellow Minimalists and Conceptualists Dan Flavin, Sol LeWitt, and Robert Smithson, which added to the project's many manifestations in its early years.

Graham has referred to *Homes for America* variously as "architectural alignments," photographs, an article, and minimal art. His use of photography located some common ground among these definitions, though it cannot be overemphasized that his decision to use an Instamatic camera and slide format had the effect of negating not just fine-art photography but also the conventions and competencies of the visual arts. Graham's was a deskilled, anti-aesthetic use of a readily available consumer technology. Like the subject and medium of the series, the maker himself occupied a relatively marginal position during the 1960s. Graham was an autodidact with a terminal high school education and no formal art training, and in his early twenties, he left his native New Jersey for the Lower East Side of Manhattan.[4] When he began *Homes for America* in 1965–66, Graham was known not so much as an artist than as an emerging critic and former director of the short-lived John Daniels Gallery, where he had mounted some of the earliest exhibitions of Minimalist art, including Sol LeWitt's first one-man show.[5]

It is interesting to consider how the Daniels context would have supported his modest project in serial photography. During evenings at Smithson's and Holt's loft, for instance, artists frequently presented their new work in the form of slides. The presentation of Graham's series was different. Instead of using the slide format as a mere vehicle that re-presented a physical work of art located, say, in a studio or gallery space, Graham positioned his slides *as* the work itself, a low-tech, luminous commentary upon debased architectural phenomena with an allegorical nod toward contemporary art (Judd's "boxes," Flavin's "lights," or LeWitt's "booths"). With these slides, Graham also recognized something fundamental about the way art reproductions accrue value and meaning as they circulate. It was not only the exhibition of the most contemporary work but also its later reproduction and critical assessment that ensured the artwork's lasting interest and legitimation, a fact that may have informed his decision to present *Homes for America* in a magazine and as a slide-projection piece.[6] Indeed, these images—whose subject was nonartistic, whose maker was not an artist, and

whose medium adapted a functional form of photography in the service of illustration and reproduction—gained their status as art only through their circulation in such varied forms, refractions of context and discipline that have been emblematic of contemporary art since the 1960s.   RA

1. Dan Graham, "Homes for America: Early 20th-Century Possessable House to the Quasi-Discrete Cell of '66," *Arts Magazine* 41, no. 3 (1966–67): 22. This article was the first publication of Graham's artwork and art criticism. Although *Homes for America* was begun in 1965, it is dated to 1966–67, the dates of its first exhibition and publication.

2. The series had its public debut in the *Projected Art* exhibition in the Contemporary Study Wing, Finch College Museum of Art, New York, from 8 December 1966 to 8 January 1967. Organized by Elayne Varian, this little-known, wide-ranging exhibition featured artists' films, experimental and avant-garde films, and films about artists. See Dan Graham, "Muybridge Moments: From Here to There?" *Arts Magazine* 41, no. 4 (1967): 23. For an excellent assessment of *Projected Art* and its implications for the artist film, see Eric de Bruyn, "The Filmic Anomaly: Moments in Post-Minimalism (1966–1970)" (Ph.D. diss., The Graduate School of the City University of New York, 2002). The second presentation of Graham's projections was in *Focus on Light*, 20 May–10 September 1967, at The New Jersey State Museum and Cultural Center in Trenton, New Jersey, and organized by Richard Bellamy, Lucy R. Lippard, and Leah P. Sloshberg. The screening at the Smithson and Holt loft appears to have occurred during the same period, though the exact date is not known. Robert Sobieszek cited the recollections of Sonja Flavin in conversation on 31 August 1992 as his source; see Robert Sobieszek, *Robert Smithson: Photo Works*, exhibition catalogue (Los Angeles: Los Angeles County Museum of Art; Albuquerque: University of New Mexico Press, 1993), 18 n. 31. See also Eugenie Tsai, "Interview with Dan Graham by Eugenie Tsai, New York City, October 27, 1988," in *Robert Smithson: Drawings from the Estate* (Münster: Westfälisches Landesmuseum für Kunst und Kulturgeschichte, 1989), 8–23.

3. The republication of the article in its intended form appeared in *End Moments* (New York: Dan Graham, 1969), where Graham reworked the second page of the *Arts Magazine* article, adding two of his photographs, and in *Dan Graham 1966* (New York: John Gibson, 1969).

4. Graham was born in 1942 in Urbana, Illinois, and raised in Winfield and Westfield, New Jersey. There is evidence of a biographical interpretation of the slide series; two of the photographs, for instance, were taken in Graham's high school in Westfield. In the summer of 1965, Graham lived again in Westfield after the John Daniels Gallery closed.

5. The John Daniels Gallery operated from December 1964 to June 1965. See Dan Graham, "My Works for Magazine Pages: 'A History of Conceptual Art,'" in *Dan Graham*, ed. Gary Dufour, exhibition catalogue (Perth: The Art Gallery of Western Australia, 1985), and Rhea Anastas, "Chronology of Works and Writings, 1965–2000," in *Dan Graham: Works, 1965–2000*, ed. Marianne Brouwer and Rhea Anastas, exhibition catalogue (Düsseldorf: Richter Verlag, 2001), 88–89.

6. See Graham, "My Works for Magazine Pages."

# Louise Lawler

*American, born 1947*

## External Stimulation, 1994–2005

Seven-minute projection shown at regular intervals on building exterior

Courtesy the artist and Metro Pictures, New York

*Salon Hodler,* still from *External Stimulation,* 1994–2005

The system of art is the subject of art for Louise Lawler. Best known for her large-scale Cibachrome photographs of collectors' homes, gallery storage, and museum spaces, Lawler tracks how art is distributed and where it lands, highlighting its role as decoration, status symbol, and object of contemplation. She makes glossy, color-saturated images that look as if they had been peeled back from an annual report or advertising brochure and enlarged. Far from adopting the flat-footed frontality that defines the way art images are conventionally reproduced, however, Lawler angles in on her subjects, revealing how art lives as a commodity among other domestic relics or as a preserved artifact wrapped in plastic and labeled. The faces of owners and proprietors are never visible in her photographs, though they are implicit everywhere. Art serves personal as well as institutional needs, and Lawler foregrounds that reality in what and how she photographs.

Display techniques play an important role in Lawler's work, which fixates as much on wall labels, frames, and Plexiglas coverings as it does on the art itself. As a means of both distribution and aggrandizement, photography serves Lawler's interest in the effects of presentation as well. The photographic image offers a way to put privately held subjects on view to a larger audience, but it also records how objects in the world relate to one another. Lawler's images tell us, for example, that some museums encase their Degas sculptures in glass vitrines, requiring the simultaneous experience of the artwork and its protective container. But they also convert those cases into something aesthetic—elements of composition as well as critique. The pictures can be stunningly gorgeous, revealing Lawler's grasp of commerce as a marketplace activity as well as a *look*. In the late 1970s, she threw a light projection from the top floor of a Los Angeles department store to a theater facade across the street, situating her work between two realms of artifice—that of the mannequin and that of the performer. The project was brief and site-specific, but it exposed her early fascination with how something as simple as light can turn a subject into a stage. The project was

typical of Lawler's work in that it underscored how surfaces ("images") could be manipulated to draw out a new experience of their underlying content.

In *External Stimulation*, originally shown at Metro Pictures in New York, Lawler combined her knowledge of photography with her interest in the dramatic effects of projection. The images—which were most visible at night, when the business was closed—included, among others, an interior view of a collector's home, which appeared to float in the darkness of the gallery space. The huge scale and seemingly out-of-place domestic content underscored the role of the gallery in fulfilling private collectors' ownership desires. While suggesting the exclusivity of the art world and the tastes of its patrons, the work was also highly visible and thus accessible to any passerby. In this way, it reinforced some of the socially engaged themes of art in the 1980s, art that took up its own privileged role within city institutions. (See, for example, Molly Warnock's description of Krzysztof Wodiczko's *Real Estate Projection* in this volume.) By using projection, Lawler made art that took place inside and outside the gallery system simultaneously, something that could be seen but not easily purchased. She capitalized on the storefront window as a prominent vehicle for display. Indeed, in an earlier collaboration with the artist Allan McCollum, Lawler played up the fact that, as she put it, "the gallery is a kind of backdrop or stage—incorporating stage lights and painted pedestals, displaying the objects in a sort-of walk-in advertisement."[1] The storefront—particularly in the SoHo district, which has since become a shopper's paradise—serves to promote objects of desire as buyable goods. Lawler's projection did not so much sell as confound and complicate expectations of what constitutes art and why we long to own it. Her images were seductively vibrant—and totally elusive.

The portability of slide projection allows Lawler's works to migrate to other locations, opening up new possibilities for critique. "External stimulations" may thus appear in cinemas or on public buildings. In a world increasingly consumed by a stream of images, Lawler's monumental frames have a reverse effect: they grab attention through their stillness and enigmatic content on a public level. Much has been written about the spectacular aspects of Lawler's work, but her ephemeral projections offer none of the blind gratification created by the mainstream media. The only thing she is peddling is critical currency.    DA

Installation view of *External Stimulation* at Metro Pictures, New York, 26 February– 26 March 1994

1. Martha Buskirk, "Interviews with Sherrie Levine, Louise Lawler, and Fred Wilson," *October* 70 (Fall 1994): 106.

# Helen Levitt

*American, born 1913*

## Projects: Helen Levitt in Color, 1971–74

Forty color photographs shown in continuous projection

The Museum of Modern Art, New York; courtesy the photographer

The vignettes of city life that Helen Levitt photographs hold the deepest themes in the smallest gestures—a sidelong glance, a peal of laughter, a pair of crossed legs. Set against the scenic and not-so-scenic stage of New York neighborhoods, Levitt's pictures gauge life as a progression of time and human relationships. Her pictures are filled with children and old people hanging out of windows or sitting on stoops watching the day unfold. Since she began taking pictures in the thirties (she bought her first camera, a Voigtlander, in 1934), Levitt has found in these everyday impressions signs of larger themes, not only those of life and death but also ways of survival. Her pictures hint at how games of distraction face off against the brutal reality of poverty and idleness. Yet they are hopeful images, too, about getting along and finding pleasure in the unexpected happenstance of the everyday.

For most of her career, Levitt photographed in black and white, distilling her compositions into subtle gradations and contrasts. That all changed when she received a Guggenheim award in 1959 (renewed the following year), which she used to explore color for the first time. Levitt saw color as "more real,"[1] meaning that it seemed closer to the vividness of contemporary life. Color served to bring out yet another aspect of people and their lived environments, though it never overpowered a photograph's overall purpose. Thus, one cannot identify a "Levitt palette"[2]—only the artist's willingness to see a part of life that cannot be conveyed in black and white. Levitt largely shot in color slides, eventually preferring Ektagraphic film for its high speed and versatility. Making photographic prints was an expensive undertaking until well into the 1970s, so many of her pictures stayed in slide form until some explicit need required printing them on paper. In 1974, The Museum of Modern Art screened a group of her slides in one of its *Projects* exhibitions, *Helen Levitt in Color* (16 September–20 October). As Levitt herself is quick to point out, this slide show was simply a means to keep the format consistent between production and display phases. It was also highly economical, allowing many pictures to appear in the same space over a relatively short period of time.

Slide projection created an entirely new viewing context for Levitt's work, however. The carousel clicks pictures in time, evoking the sound of a camera shutter releasing and thus engendering a variant of the fleeting encounter so integral to Levitt's photography. Levitt, who was known to edit her slides by holding them up against a white piece of paper, refused to see projection as an aesthetic statement. Nevertheless, she understood that images thrown by the light of a projector had a unique resonance and scale. A filmmaker with a background in editing, Levitt worked as a film cutter in 1941. The trimming of film strips (which, coincidentally, was how slides were originally made in the 1930s) required keen, decisive moves, which she possessed both in her selection process and picture taking. Projected slides accentuated her penchant for precision by offering both luminosity and large-scale detail, which Levitt loaded into her images. And though a print underscores intimacy, a projection delivers pictures on a more public level, a feature that reinforces the communal nature of Levitt's many street photographs. Through slides, the world of the city is transposed to the gallery—not as isolated pictures hanging in frames, but as a series of constantly moving glimpses that flash and disappear, like the brief engagements people have on the sidewalks and subways of New York.

It was unusual for photographers to show their work as slides in the 1970s, even though many used slide film while taking their pictures. There are several possible explanations for this. Though artists (and particularly Conceptualists) ostensibly resisted the production of artifacts that could be bought and sold, photographers cracking into a new market of possible collectors continued to value the print as a material item that, like a painting or some other work on paper, belonged in a frame. Photographers traditionally produced their work, too, for printed outlets—magazines, books, and newspapers. To many, pictures are best seen on pages, where life can hold still for contemplation, however momentarily. Levitt understood the range of options available to her as an artist, and she found in slide projection a means to intensify her view of the world and bring to light the color of city life.  DA

Stills from *Projects: Helen Levitt in Color*

1. Helen Levitt, telephone interview by Darsie Alexander, 14 October 2003.
2. See Maria Morris Hambourg's discussion of Levitt's color work in "Helen Levitt: A Life in Part," in *Helen Levitt,* by Sandra A. Phillips and Maria Morris Hambourg, exhibition catalogue (New York: The Metropolitan Museum of Art; San Francisco: San Francisco Museum of Modern Art, 1991), 6.

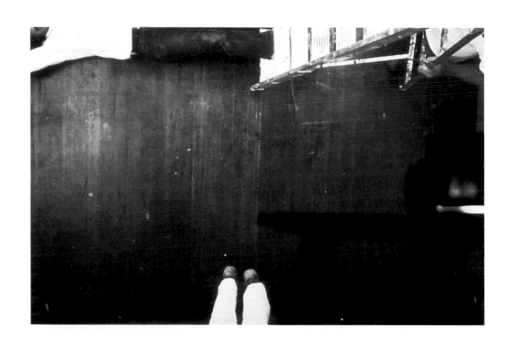

# James Melchert

*American, born 1930*

Location Project #4,
Powerhouse Gallery,
1971

Eighty-one projected color
slides with mirror

Courtesy the artist, Oakland,
California

James Melchert's work is a form of choreographed play that begins with several subjects engaged in a physical activity and ends with an installation of slides on a wall that both document and transform their actions. During the 1960s and 1970s, as artists were leaving their paintbrushes behind, more work emerged that deliberately linked the process of making art to other forms of social interaction, dialogue, and experimentation. The gradual disintegration of the boundary between art and life called for a new incorporation of materials and subject matter drawn from the artist's personal and cultural experience. All of Melchert's subjects were his colleagues and friends, and their performances underscore both familiarity and shared pleasure. In the hundreds of frames that constitute his many slide works, we see people rolling on the floor, pulling string against the grass, and sitting around a table. For all the hard work, they seem to be having fun.

Since starting his career in the 1960s, Melchert has investigated what-if scenarios as the basis of his art. The first works were explorations of game formats: a chessboard made with moveable clay pieces, a slide kit that could be edited to create any number of configurations and outcomes. Melchert's turn to slides as a principal vehicle came somewhat by accident—quite literally as he was "staring at the wall."[1] What if the plane of the wall became more than a place to hang one's work but a dimensional surface for artistic activity? Melchert began taking pictures of people moving across the walls, and he projected the images back into the spaces where they originated. The results produced a startling juxtaposition of the physical wall and the projected image, which converted its features into ephemeral illusions. The human subjects he photographed experienced an even greater metamorphosis in slides as their physical movements in space became frozen, two-dimensional stills. The experiments evolved into "location projects," which linked specific slide works to sites that served as concrete sources as well as screens for his projections.

Installation view of *Location Project #3, Powerhouse Gallery*, 1971

*Location Project #4*—at the Powerhouse Gallery, University of California, Berkeley—transferred Melchert's wall theme to a horizontal platform, turning it from a location to a dislocation. The project consists of an eighty-one-frame cycle that is projected using a refracting device tilted at a 45° angle. The pictures land on the floor and fill it with ephemeral images of bodies in tableau-like poses. An upright ladder pushes against the plane of one image, mimicking the viewer's orientation while remaining a thin and permeable projection surface. Over the cycle, the figures change positions, as if spelling out a cryptic message with their legs, arms, and torsos. Like the slides themselves, Melchert's performers are divisible elements that can be scrambled and rearranged, forming new figural compositions each time. On the one hand, the carousel keeps their fragmentary poses moving; on the other, they are isolated by time and dimensionally flattened. The game here is an optical illusion of compressed representational space inside "real" space—the architecture that we inhabit.

Melchert's slide experiments came about during a time in which the rules of artistic production were undergoing reevaluation and dramatic revision. Slides presented a novel format for an aesthetic endeavor, and as a spatial/durational medium, they represented an effective means of dealing with performance-related themes. They also allowed Melchert to explore the role of the artist. Dressed in conventional work clothes, artists populate nearly every one of his images. They engage in the most rudimentary physical acts—opening and closing doors, jumping, and measuring random objects. These moves serve no clearly utilitarian purpose, and Melchert offers no explanation for them. Like others of his generation, he believed in the possibility of linking art with the most routine gestures. These gestures are the foundation for Melchert's work—and the visual as well as philosophical possibilities it opens up.   DA

1. James Melchert, telephone interview by Darsie Alexander, 26 June 2003.

Installation view of *Location Project #4, Powerhouse Gallery*

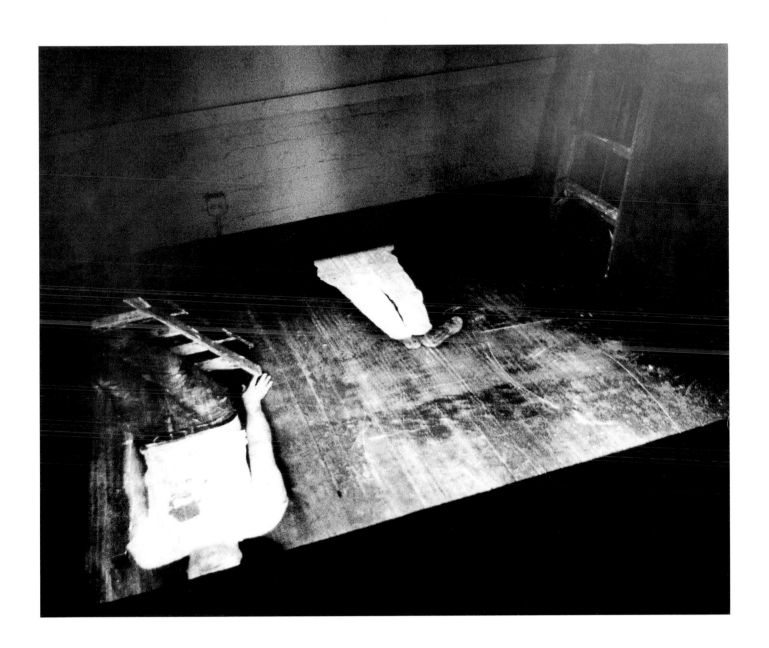

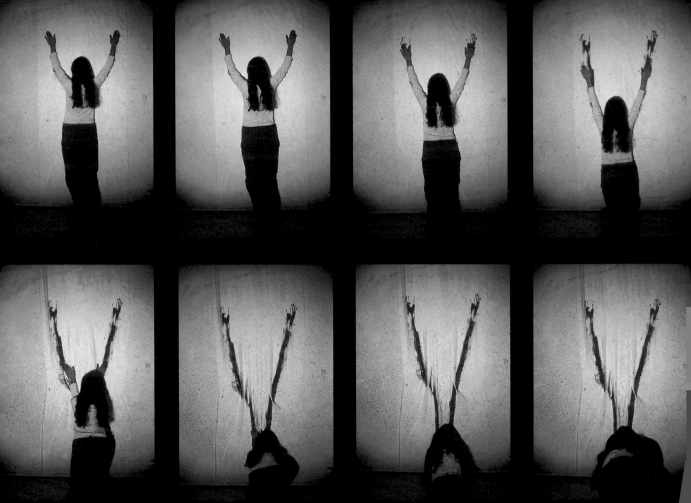

# Ana Mendieta

*American, born Cuba, 1948–1985*

**Untitled (Body Tracks), 1974**

Nine projected color slides

Courtesy the Estate of Ana Mendieta and Galerie Lelong, New York

Original documentation photographs by Hans Breder

The rise of feminism opened up new issues and strategies for performance artists during the 1970s. As a genre founded on the body of the artist as a primary agent, performance art supported subjectivity in all its physical and psychological forms, giving women artists a platform from which to investigate normally restricted or taboo subject matter. The personal-made-political message of much feminist work necessitated exposure on an intimate level, with the artist transforming her body into a contested site, medium, and subject. Though not all feminist works qualified as radical acts of transgression, the concept of change and catharsis informed the themes and material choices of many artists.

Ana Mendieta's work found its anchor in this principle of metamorphosis. She began as a painter and studied intermedia at the University of Iowa, pursuing a fine arts master's degree that encouraged crossing disciplines and fields of interest. While in the Midwest, Mendieta gained her footing as an artist, exploring the possibilities of art as a temporal process that could occur as easily outdoors as in the studio. She identified the earth as her support and her body as a tool for making sculptural impressions in nature. Belying the influence of Robert Smithson's earthworks on her art, her performances resulted in physical imprints that would remain only as long as the elements allowed, giving way to the eventuality of rain, wind, and snow. These actions centered on themes of transmogrification and decay, and they often possessed the qualities of ritual, with Mendieta playing the parts of agent and victim. Violence counters nature's regenerative powers in her work, where a cut in the earth's surface can be read as either a grave or a birthing hole. She often made her mark with the blood of animals, soaked into a canvas or covering her body. Few people witnessed these early performances, which occurred in remote locations or private studios. The immediate gratification of an audience was not Mendieta's priority—nor was the validation of the commercial art world. The work was privately investigative, as if to challenge personal as well as artistic limits.

Photography was an important documentary vehicle for Mendieta as well as a means by which to make her work accessible in some way. A close relationship with the artist and photographer Hans Breder at the University of Iowa resulted in the thorough recording of her performances there during the early 1970s. Though Mendieta would often perform spontaneously, she knew the power of images and articulated her preferences for tight cropping and progressive sequences to Breder. Sometimes he would draw an outline in the sand, and Mendieta would configure herself within its boundaries as he took the pictures.[1] This performing-while-being-photographed is visibly transcribed in a *Body Tracks* action documented in 1974. The event, which took place in a studio, involved the artist's dragging her arms, covered with beef blood, down a white sheet pinned onto the wall. The pictures show Mendieta from behind at successive stages, each frame marking a new step as the artist shifts from a vertical to a prone position. Though the sequence promotes the theme of the blood-trace as a recurring motif for Mendieta, it also functions as a form of staged imagery. At several points, Mendieta appears to be drawing over lines already made, as if to acknowledge the inevitable reception of the work as a series of flat pictures that require legibility. Indeed, this is how we know the work today; the trace she made was as photographic as it was ritualistic.

Mendieta used slides regularly to record and show her work. It is possible that, like other artists working in three dimensions, she preferred the color quality of slides and their potential to give scale to her work. Breder also worked with slides, using them for documentation and as projections to be incorporated into his performances. Slides allowed these artists to extend the life of a work, to give it a different incarnation. *Body Tracks,* for example, existed not only as distinct performances but also in the form of residual artifacts. (In some cases, the fabric she utilized became banners hoisted up poles for display.) This constant recycling of formats and ideas added a complexity to Mendieta's output, particularly for critics examining her work posthumously. In the absence of the artist herself, where does the artwork reside? For Mendieta, it is in a range of elusive places.    DA

1. Hans Breder, telephone interview by Darsie Alexander, 18 February 2004.

Installation view of
*Untitled (Body Tracks)*

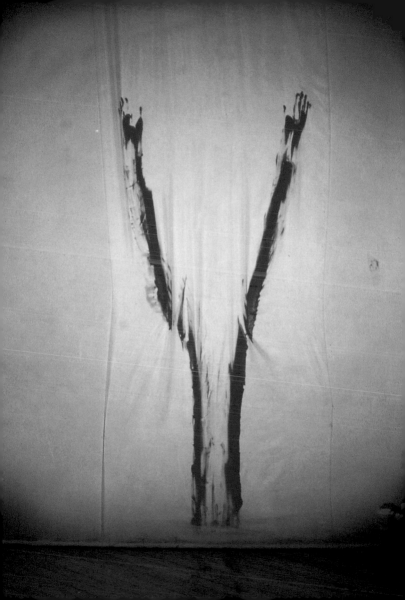

# Jonathan Monk
*British, born 1969*

## One Moment in Time (Kitchen), 2002

Eighty projected color slides, slide projector, and pedestal

Courtesy the artist and Casey Kaplan Gallery, New York

The familiar image of a middle-class family gathered around an old slide machine to view snapshots of a summer vacation may be an increasingly distant memory, but it is an enduring scene that played out in countless advertising brochures and 1950s reruns. The pictures are always perfect—"treasured" moments of life, set to the beat of the slide carousel—with friends and relatives looking on with a mixture of approval and anticipation as each waits to see him- or herself on the silver of the projection screen. There is always a narrator (or several) offering a running commentary of "who, what, where" and whether the image is "right" according to memory or "wrong" according to impression. Slides offer a way of reliving the past, however subjectively.

The associations carried by slides— whether experienced as lived reality, suggested by the media, or some combination of both—are the tropes of artist Jonathan Monk, whose work imbues obsolete technologies with personal narrative designed to preserve those bygone moments. History is fluid as he moves between artistic and biographical modes of reference: the Rubik's Cube from the 1980s, the slide carousel of the 1960s, the 1950s snapshot. Embodied in these objects is a finite cycle of life and death, as trends are popularized and then replaced by new fashions and phases. This is as true for art as it is for commodities, as Monk's own creative influences make clear. In his vernacular appropriations and his assimilation of the readymade, he evokes the Conceptualists; in his ordering impulse can be found remnants of Minimalism. Yet Monk taps into a wide historical time span, blending critique with nostalgia. Slide projection is not simply a vehicle for personal anecdotes. It links with a visual tradition that embraced the avant-garde as well as the everyday.

The generalized phenomenon of the family slide show is the crux of *One Moment in Time (Kitchen)*, a series of eighty snapshots turned into words or phrases. Silhouetted against a lichen-green color resembling that of elementary-school blackboards, the projections are simple descriptions relayed to the artist

by his sister over the telephone as she chronicles the imagistic contents of their mother's kitchen. Of course, the space is filled with snaps and postcards from the artist's growing-up years: "Dad as the captain of a sailing ship," "You wearing stupid glasses." The absence of actual pictures makes the slide show all the more enticing, not only because the viewer must fill in the gaps but also because, in so doing, he or she must confront an internal reserve of pictures to put in their place. The fact that the process of imagining and projecting is relatively easy speaks to the universality of snapshots (if not the slide projector) among the middle class. Few people in the industrialized world today lack cameras of their own, and Monk banks on the likelihood that their amateur snapshots probably look a lot like his, even though, in the end, he doesn't show us any.

The apparent graphic and technological simplicity of Monk's piece is complicated by the fact that it is also about mediation: the image displayed by the parent becomes the sister's over-the-phone description transferred into blocky, typeset letters thrown by a projector. At each stage of this progression, reality breaks down. Did the sister correctly attribute the image, and did Monk capture her words exactly? For Monk, the process of translation is filled with kinks and idiosyncrasies. *One Moment in Time (Kitchen)* pays homage to a now-antiquated apparatus while exploring its complex terms of representation.  DA

Installation view of *One Moment in Time (Kitchen)*

Mum and dad with Sally

# Dennis Oppenheim

*American, born 1938*

## Ground Gel, 1972

One hundred sixty projected
color slides and dissolve

Courtesy the artist, New York

When artists like Dennis Oppenheim started their careers in the late 1960s, they sought to differentiate themselves from their immediate predecessors—not only the individuals whose formidable presences had defined history but also the ways in which their work shaped conceptions of what art should be. In the wake of the bold lines and immense canvases of such artists as Jackson Pollock, for example, this younger generation made art that resisted the climactic statement of "genius" in favor of subtler gestures that would change the dynamic between people and their normative environments. Oppenheim began his career as a sculptor but abandoned the path of three-dimensional design in 1967 to make land art instead. His first works involved excavating earth, leaving marks that also served as voids in its surface. Subsequent works engaged the act of temporarily removing or displacing the earth as well. Oppenheim staunchly refused to make objects that would simply "embellish" the environment. Rather, he was attempting, in his words, to "get below ground level."[1]

The slide piece *Ground Gel* takes the theme of the earth as a literal backdrop for the actions of two spinning figures, who seem to merge with the ground as well as each other as the slides progress. The pictures were taken from an aerial position, at once suggesting surveillance photographs and microscopy—two areas of science that aid in our understanding of the "nature of life" as seen from extreme vantage points. As the images unfold, the bodies coalesce, at times resembling cells or amoebas. Yet the "nature" at work here is between parent and child. The subjects are the artist and his young daughter Chandra, held together by biology and fused together by imagery.

The idea of energy and matter transferal is an underlying theme for Oppenheim, whose work involved taking objects and activities out of their ordinary contexts. He often deliberately extracted things from their "proper" places to challenge assumptions about space and human interaction, for example. These forms of displacement art could have both subtle and overt consequences,

135

depending on the site and numbers of people involved. Some pieces, performed in remote locations, included acts like cutting a hole in the snow covering a river, a formidable undertaking that only a few could witness. But other works had more explicit social implications, such as those affecting the movements of people—or even the outcome of a farmer's crop. Over time, he focused more on people as his subject matter, especially his family, with whom he shared an ongoing experience of art. In a work made with his son, Erik, *Feed-back Situation* (1971), Oppenheim drew lines on the boy's back that the child, interpreting how the marks felt on his skin, then transferred to the wall. Not only do such works introduce other sensory experiences beyond the strictly visual, but they also rely on a secondary messenger and agent for their existence.

*Ground Gel* suggests a process of transferal through the creative act as well as through the reproductive act of making multiple pictures. Oppenheim relied heavily on photography to document his actions and used the mechanisms of the camera to give them a new form. The way in which he displayed the work, for example, changed its perceptual orientation from "bird's-eye view" (as captured by the images) to "eye-level view" (as experienced through lateral projection). Of the various incarnations that exist of this piece, including a photo-panel, none stands out as "the" work of art. Rather, all the variants are part of an idea subject to constant reinvention. In slide form, the artist found the perfect metaphor for themes of separateness and interdependence, with the images shifting and dissolving like the bodies they depict.     DA

1. Alain Parent, *Dennis Oppenheim*, exhibition
   catalogue (Montreal: Musée d'art contemporain,
   1978), 10.

*Slide Dissolve Sequence for Ground Gel*, 1972, seventy-four color prints, one gelatin silver print, and ink on paperboard

Slide Display Sequence for GROUND GEL, 1972. Dennis Oppenheim and Chandra Oppenheim. 35mm color
film with sound. Federal from soundtrack: I don't want to be able to see you...want you to go
past me...want to go out there and touch you...You're going past me now...You're going to take
me past myself...I'm going with you...I can't see you now...I want to go out there and touch
you...I'm touching you out there...I see me with you...You've taken me with you...I'm out there
with you...I see you out there...I can touch you now...You're taken me with you...
You're taken me past you...

# Jack Smith

*American, 1932–1989*

**Boiled Lobster Color Slide Show, 1970–88**

Forty-eight projected color slides

Courtesy the Plaster Foundation, New York

Jack Smith loved to edit. He obsessively worked over images, arranging and rearranging, mixing and matching them into sequences that created new visual relationships and clues to fantastical narratives. Deliberate and complex, this editorial process yielded multiple artworks along the way to a "finished" product. At film screenings, for example, he didn't show a film, he dramatized it. He transformed collective viewing into live performance, cutting and splicing footage as the film rolled on, posing and gesturing, commenting on changes, directing actors to read scripts without rehearsal, and introducing sound and music. He stated, "finishing a film is not a matter of years. It is a matter of decades."[1] And indeed, most of Smith's films were left unfinished, such as *Buzzards over Baghdad* (started in 1952), *Normal Love* (1963), and *No President* (1969), among other projects. Given Smith's impulse to make revision an aspect of his art and his careful crafting of images, it is no surprise that the easy-to-handle, flexible, and cheap slide format would attract him. *Boiled Lobster Color Slide Show*, a carousel of slides found in Smith's apartment after his death from AIDS in 1989, is one of the few slide works in which the artist's selection and ordering of slides remain intact. Essentially unfinished, the work shows a moment of art before the next reedit and performance.

Jack Smith lived two artistic lives: one in the 1960s, as an experimental avant-garde filmmaker, and the other in the late 1970s and 1980s, as an East Village shaman. His art emerged the first time as farce and the second time as critical irony. In both periods, he used kitsch as a sensual and audacious antidote to one academic generation's uninspired modernist formalism and another's language-based theory and institutional critique. During his first life, Smith's film masterpiece and cult classic, *Flaming Creatures* (1962–64), granted him instant underground fame when it was banned in New York for its sexually provocative content. Concurrently, it gained critical credibility with its decadent attack on film's fine-art sensibility. Susan Sontag described the film as "a triumphant

example of an aesthetic vision of the world,"[2] and no doubt it was in her mind when she wrote her famous essay "Notes on Camp," which explored a new artistic sensibility fixated on the unnatural, exaggerated, and artificial. Decades later, Smith's *Boiled Lobster Color Slide Show* retains *Flaming Creatures'* overwhelming visual luxury. The slides are rich with layered textures and color, shifting perspectives, and exotic tableaux. A plastic toy lobster and crab, an Easter basket, and a silver tree, among other objects, are displayed with the care typically bestowed upon crown jewels.

*Boiled Lobster Color Slide Show* resists Sontag's claim that "camp" style supersedes content and that its "sensibility is disengaged, depoliticized—or at least apolitical."[3] Behind the work's obscure narrative is clearly a critique of the slumlords who were quickly gentrifying Smith's Lower East Side neighborhood in the 1980s, provoking protests from artists—including a faction of Collaborative Projects, Inc. (Colab), who illegally occupied and mounted their *Real Estate Show* (1980) in an unused building. Outfitted as a sheik and surrounded by dime-store props, Smith stands center stage in a mock narrative of revolutionary rebellion against the landlords of the world. It is hard to take Smith seriously because, on film as in life, he played the part of the over-the-top, exotic, histrionic—and, above all, glamorous—creature. But Smith's critique of landlordism is serious and sustained throughout his work of the period. In his iconography, the spineless bottom-feeding lobster symbolizes the landlord as the premier example of capitalist greed and corruption. Rejecting the graphically honed text of high modernism and the period's postmodern chic, Smith mimics real estate advertising with a homemade sign that reads "Select Now! A Deposit Holds Your Selection." He creates a homegrown repertoire of characters and story lines to rage against the inequities and travesties of capitalism with an optimism that only an artist totally sold on dystopia could possess.    DL

1. Quoted from a grant application by Jack Smith. See *Wait for Me at the Bottom of the Pool: The Writings of Jack Smith*, ed. J. Hoberman and Edward Leffingwell (London: Serpent's Tail in collaboration with The Institute for Contemporary Art/P.S. 1 Museum, 1997), 145.

2. See Susan Sontag, "Jack Smith's Flaming Creatures" (1964), in *Against Interpretation* (New York: Anchor Books, 1990), 231.

3. See Sontag's "Notes on Camp" (1964), in *Against Interpretation*, 277.

Still from *Boiled Lobster Color Slide Show*

# Robert Smithson

*American, 1938–1973*

## Hotel Palenque, 1969–72

Thirty-one projected color slides and audio CD

Solomon R. Guggenheim Museum, New York: Purchased with funds contributed by the International Director's Council and Executive Committee Members: Edythe Broad, Henry Buhl, Elaine Terner Cooper, Linda Fischbach, Ronnie Heyman, Dakis Joannou, Cindy Johnson, Barbara Lane, Linda Macklowe, Brian McIver, Peter Norton, Willem Peppler, Denise Rich, Rachel Rudin, David Teiger, Ginny Williams, Elliot Wolk

*The world is slowly destroying itself.*
*The catastrophe comes suddenly, but slowly.*

—*Robert Smithson*

In 1972, a group of architecture students at the University of Utah gathered for what they thought was to be a presentation by artist Robert Smithson on Mayan archaeological sites. Instead, they were treated to a slide lecture on the Hotel Palenque, where Smithson had stayed during a 1969 visit to Mexico with his wife, the sculptor Nancy Holt, and the art dealer Virginia Dwan. The installation *Hotel Palenque* comprises his slides and a synchronized audio recording of his unscripted talk.

In word and image, Smithson describes the hotel's sprawling, haphazard accumulation of structures—lobby and guest rooms, garages and dance hall, swimming pool and outbuildings—in their various states of disuse, decline, and decrepitude. At the time his travelogue was prepared, parts of the hotel were brand new, some were being repaired or demolished, and still others were in ruins, almost completely reclaimed by the Chiapas landscape.

Though Smithson's analysis is shot through with dark humor and peppered with tongue-in-cheek observations that at times border on the absurd, he seems to have been genuinely fascinated by the hotel, which he took to be an example of "de-architecturization"—entropy made visible. He describes the Hotel Palenque as a living monument to the irresistible forces that bring about the eventual destruction and disappearance of all discrete things; at the same time, the site commemorates the creative, productive human energies that are marshaled to stave off the inevitable end. "The interesting thing about this place," he says with regard to this fundamental dynamic, "is that there is no point of rest."

Much of Smithson's mature work explores manifestations of entropic processes in nature and in the built environment. From his "nonsites"—sculptural displacements of natural materials from remote environments to carefully

mapped galleries—to earthworks, his monumental outdoor sculptures in simple, symbolic shapes made of stone, earth, and other natural materials, he opened his systems and structures to disorder and decay. This was his decisive rift with then-dominant Minimalism, which presumed to produce static, monolithic objects for contemplation and thus to promote phenomenology, the study of fundamental structures of sensory experience as they shape individual consciousness. Speaking on behalf of this Minimalist hermeticism, sculptor and critic Donald Judd took the opportunity to dismiss Smithson's avowed interests as regressive: "For 200 years or so art has been freeing itself from being obliged to say things about the world which are properly in the area of science. Some recent artists, Robert Smithson for one, have revived this dying anthropomorphism by incorporating scientific ideas and terms in their work."[1]

As *Hotel Palenque* was produced less than one year before Smithson's tragic death in an airplane crash, it is tempting to think of the piece as a uniquely resonant example of the artist's enduring interest in another philosophical pursuit: dialectic. Dialectic is an exchange of propositions and counterpropositions in argumentation that intends to produce new, more compelling understandings of aspects of the world through the synthesis of opposing assertions about them. In *Hotel Palenque,* Smithson explores a most profound dialectic—the dialectic of existence.

Like Hegel, the great dialectician of the late eighteenth and early nineteenth centuries, Smithson recognized that existence is neither pure being nor its opposite, pure nothingness. Rather, it is a steady state of becoming: that which is coming into existence is always, at the same time, approaching a state of nonexistence, as in the cycle of human birth and death. The process of de-architecturization Smithson witnessed at the Hotel Palenque and its proprietors' ceaseless efforts to slow it seemed to him exemplary of this synthesis—a near-steady state of becoming. As the epigraph above suggests, Smithson acknowledged the inevitable triumph of entropy, but in his improvisational riff, *Hotel Palenque,* he also celebrates the human will to prolong the inevitable.   TC

1. Donald Judd, *Complete Writings, 1975–1986*
(Eindhoven: Van Abbemuseum, 1987), 82.

Still from *Hotel Palenque*

# Krzysztof Wodiczko

*Polish, born 1943*

**The Real Estate Projection, 1987**

Four projected color slides

Collection Fundació Antoni Tàpies, Barcelona

Krzysztof Wodiczko's best-known works of the past two decades are his public projections—the large-scale, politically charged works the artist has staged at night on the facades of buildings and monuments around the world. Somewhat less well known but no less integral to his body of work are the slide installations Wodiczko has staged throughout the same period on the interior surfaces of museums and galleries. A crucial example of Wodiczko's work in the latter category, *The Real Estate Projection,* points to the artist's long-standing interest in the power of the projected image to reveal or "unmask" the implicit workings of the ground—the institutional and material site or system—that is both its support and its frame.

Wodiczko's projected artworks are always designed with a specific site in mind. *The Real Estate Projection* was first shown at the Hal Bromm Gallery in New York's East Village. In 1987, the neighborhood to which this space belonged was in the first flush of a process of gentrification that would eventually force many of the area's low-income residents from their homes. This process, to some extent, was precipitated by the arrival of galleries such as Hal Bromm's into what had long been a working-class community,[1] and Wodiczko's work makes an issue of the difficult, largely unacknowledged relationship between the gallery's inside and its outside.

To stage *The Real Estate Projection,* Wodiczko blackened the windows of the gallery space, turning this "white cube" into a hermetically sealed black box. These windows were then replaced by images of windows thrown by slide projectors onto two adjacent walls in the darkened space. Two were shown as open, with blinds drawn back; the third, perpendicular to this pair in a corner space, was partially obscured by a slatted shade. All three windows revealed neatly framed views of a derelict building as spied from a newly renovated apartment building near the gallery. Superimposed onto the sill of one projected window was another image: a pair of binoculars atop two real estate–related magazines.

In its particular historical moment, the urban iconography of *The Real Estate Projection* demanded—and to some extent still demands—to be seen within the horizon of then-raging debates about gentrification, homelessness, and the mutual dependency and complicity of the art and real estate markets in contemporary New York. Formally and phenomenologically, however, the interest of this work exceeds the local terms of its original context, as it opens up a host of questions about the relation of the medium of slide projection to an embodied viewer. Wodiczko's windows simultaneously incite and frustrate a voyeuristic impulse to look through the work's projected panes, as do the invitingly placed binoculars. Yet to stand in front of any one of these windows is to be implicated bodily, as the viewer would block the projector's beam and so become the support for its image. At the same time, the work appears to play on multiple senses of the term "projection." Itself a projected work, *The Real Estate Projection* also captures allegorically both the market logic of real estate speculation and the psychological dynamics of projection on which our dealings with the world actually depend.    MW

1. For more on the socioeconomic conditions attending the growth of the East Village art scene, see Rosalyn Deutsche and Cara Gendel Ryan's groundbreaking essay, "The Fine Art of Gentrification," *October* 31 (Winter 1984): 91–111.

Installation view of *The Real Estate Projection*

# contributors

*Darsie Alexander,* Curator of Prints, Drawings, and Photographs at The Baltimore Museum of Art, is a specialist in contemporary and vernacular photography. She has written on the development of posed photographs, representations of the body, and the role of documentation photographs in 1970s performance art.

*Rhea Anastas,* Visiting Professor of Art History at the Center for Curatorial Studies, Bard College, New York, is the co-editor of *Dan Graham: Works, 1965–2000* and the author of essays and articles on contemporary art.

*Thom Collins,* Executive Director of the Contemporary Museum, Baltimore, has organized numerous group exhibitions, particularly focusing on those that explore contemporary art's relationship to space and geographical identity.

*Charles Harrison,* Professor of History and Theory of Art at the Open University, London, was a contributing editor to a leading contemporary art journal, *Studio International,* from 1966 to 1975, and has published extensively on Conceptualism. He is a member of the artists' group Art & Language.

*David Little,* Director of Adult and Academic Programs at The Museum of Modern Art, New York, recently organized an exhibition on the subject of empire in contemporary video.

*Robert Storr,* Rosalie Solow Professor of Modern Art at the Institute of Fine Arts, New York University, has organized numerous exhibitions, including international retrospectives on Chuck Close, Tony Smith, Gerhard Richter, and Robert Ryman.

*Molly Warnock,* Ph.D. candidate in the Department of Art History at The Johns Hopkins University, was a recipient of a BMA/JHU Art History Research Fellowship.

Detail from Kodak
advertisement, 1963

# selected bibliography

Alloway, Lawrence. *5 Artists/5 Technologies.* Exhibition catalogue. Grand Rapids, Mich.: Grand Rapids Art Museum, 1979.

Ault, Julie, ed. *Alternative Art New York: 1965–1985.* Minneapolis: University of Minnesota Press in collaboration with the Drawing Center, New York, 2002.

Baker, George, ed. *James Coleman.* October Files 5. Cambridge, Mass.: MIT Press, 2003.

Bann, Stephen. "Environmental Art." *Studio International* 173 (February 1967): 78–81.

Barthes, Roland. *Camera Lucida: Reflections on Photography.* Translated by Richard Howard. New York: Hill and Wang, 1981.

Benjamin, Walter. "Art in the Age of Mechanical Reproduction." In *Illuminations: Walter Benjamin, Essays and Reflections,* by Walter Benjamin, edited with an introduction by Hannah Arendt and translated by Harry Zohn. 217–51. New York: Schocken Books, 1968.

Biesenbach, Klaus, Barbara London, and Christopher Eamon. *Video Acts: Single Channel Works from the Collections of Pamela and Richard Kramlich and New Art Trust.* Exhibition catalogue. New York: P.S. 1 Contemporary Art Center, 2002.

Bohrer, Frederick N. "Photographic Perspectives: Photography and the Institutional Formation of Art History." In *Art History and Its Institutions: Foundation of a Discipline,* edited by Elizabeth Mansfield, 246–59. London: Routledge, 2002.

Borja-Villel, Manuel, and Michael Compton. *Marcel Broodthaers, Cinéma.* Barcelona: Fundació Antoni Tàpies, 1997.

Bossé, Laurence. *Peter Fischli and David Weiss.* Exhibition catalogue. Paris: Musée d'art moderne de la ville de Paris; Cologne: Verlag der Buchhandlung, Walther König, 1999.

Boswell, Peter. *Public Address: Krzysztof Wodiczko.* Exhibition catalogue. Minneapolis: Walker Art Center, 1992.

Brougher, Kerry. *Art and Film Since 1945: Hall of Mirrors*. Exhibition catalogue. Los Angeles: The Museum of Contemporary Art; New York: The Monacelli Press, 1996.

Brouwer, Marianne, and Rhea Anastas, eds. *Dan Graham: Works, 1965–2000*. Exhibition catalogue. Düsseldorf: Richter Verlag, 2001.

Buchloh, Benjamin H. D. "Memory Lessons and History Tableaux: James Coleman's Archeology of Spectacle." In *James Coleman*, 51–75. Exhibition catalogue. Barcelona: Fundació Antoni Tàpies, 1999.

Buskirk, Martha. "Interviews with Sherrie Levine, Louise Lawler, and Fred Wilson." *October* 70 (Fall 1994): 104–8.

Campany, David, ed. *Art and Photography*. New York: Phaidon Press, 2003.

Carroll, Noël. *Interpreting the Moving Image*. Cambridge: Cambridge University Press, 1998.

Christov-Bakargiev, Carolyn, and Caoimhín Mac Giolla Léith. *Willie Doherty: False Memory*. Exhibition catalogue. New York: Merrell Publishers; Dublin: Irish Museum of Modern Art, 2002.

*Cindy Sherman: The Complete Untitled Film Stills*. New York: The Museum of Modern Art, 2003.

Coe, Brian. *Cameras: From Daguerreotypes to Instant Pictures*. New York: Crown, 1978.

———. *Colour Photography: The First Hundred Years, 1840–1940*. London: Ash and Grant, 1978.

Collins, Douglas. *The Story of Kodak*. New York: Harry N. Abrams, 1990.

Crary, Jonathan. *Techniques of the Observer: On Vision and Modernity in the Nineteenth Century*. Cambridge, Mass.: MIT Press, 1994.

Danto, Arthur. *After the End of Art: Contemporary Art and the Pale of History*. Princeton: Princeton University Press, 1997.

de Bruyn, Eric. "The Filmic Anomaly: Moments in Post-Minimalism (1966–1970)." Ph.D. diss., The Graduate School of the City University of New York, 2002.

Deutsche, Rosalyn, and Cara Gendel Ryan. "The Fine Art of Gentrification." *October* 31 (Winter 1984): 91–111.

Druckery, Timothy, ed. *Electronic Culture: Technology and Visual Representation*. New York: Aperture Foundation, 1996.

*54–64: Painting and Sculpture of a Decade*. Exhibition catalogue. London: Tate Gallery, 1964.

Fogle, Douglas. *The Last Picture Show: Artists Using Photography, 1960–1982.* Exhibition catalogue. Minneapolis: Walker Art Center, 2003.

Folcy, Suzanne. *Jim Melchert: Points of View: Slide Projection Pieces.* Exhibition catalogue. San Francisco: San Francisco Museum of Art, 1975.

———. *Space/Time/Sound: Conceptual Art in the San Francisco Bay Area: The 70s.* Exhibition catalogue. San Francisco: San Francisco Museum of Modern Art, 1981.

Fried, Michael. "Art and Objecthood." *Artforum* 10 (Summer 1967): 12–23.

Friedman, Martin. *Projected Images: Peter Campus, Rockne Krebs, Paul Sharits, Michael Snow, Ted Victoria, Robert Whitman.* Exhibition catalogue. Minneapolis: Walker Art Center, 1974.

Friedman, Martin, M. M. M. Vos, and R. H. Fuchs. *Jan Dibbets.* Exhibition catalogue. Minneapolis: Walker Art Center, 1987.

Fuchs, Rudi. *Conceptual Art in the Netherlands and Belgium, 1965–1975.* Exhibition catalogue. Amsterdam: Stedelijk Museum; Rotterdam: NAi Publishers, 2002.

Gintz, Claude. "Some Remarks on So-Called 'Conceptual Art': Extracts from Unpublished Interviews with Robert Horvitz (1987) and Claude Gintz (1989)." In *L'art conceptuel: Une perspective.* Exhibition catalogue. Paris: Musée d'art moderne de la ville de Paris, 1989.

Godfrey, Tony. *Conceptual Art.* London: Phaidon Press, 1998.

Goldin, Nan. *The Ballad of Sexual Dependency.* Edited by Marvin Heiferman, Mark Holborn, and Suzanne Fletcher. New York: Aperture Foundation, 1986.

———. *I'll Be Your Mirror.* Exhibition catalogue. New York: Whitney Museum of American Art; New York: Scalo, 1996.

Goldstein, Ann, and Anne Rorimer. *Reconsidering the Object of Art: 1965–1975.* Exhibition catalogue. Los Angeles: The Museum of Contemporary Art; Cambridge, Mass.: MIT Press, 1995.

Goodman, Nelson. *Languages of Art.* Indianapolis: Hackett, 1976.

Graham, Dan. "Homes for America: Early 20th-Century Possessable House to the Quasi-Discrete Cell of '66." *Arts Magazine* 41, no. 3 (1996–67): 21–22.

———. "Muybridge Moments: From Here to There?" *Arts Magazine* 41, no. 4 (1967): 23–24.

———. "My Works for Magazine Pages: 'A History of Conceptual Art.'" In *Dan Graham,* edited by Gary Dufour. Exhibition catalogue. Perth: The Art Gallery of Western Australia, 1985.

————. "Photographs of Motion." In *Two Parallel Essays: Photographs of Motion/Two Related Projects for Slide Projector,* 1–3. New York: Multiples, 1970.

Hager, Steven. *Art After Midnight: The East Village Scene.* New York: St. Martin's Press, 1986.

Hakkens, Anna. *Marcel Broodthaers: Projections.* Exhibition catalogue. Eindhoven: Van Abbemuseum, 1994.

Heiss, Alanna. *Dennis Oppenheim: Selected Works, 1967–1990.* Exhibition catalogue. New York: The Institute for Contemporary Art/P.S. 1 Museum with Harry N. Abrams, 1992.

Hoberman, J. *On Jack Smith's Flaming Creatures (and Other Secret-Flix of Cinemaroc).* New York: Granary Books, 2001.

Hoberman, J., and Edward Leffingwell, eds. *Wait for Me at the Bottom of the Pool: The Writings of Jack Smith.* London: Serpent's Tail in collaboration with The Institute for Contemporary Art/P.S. 1 Museum, 1997.

Holert, Tom. "Nan Goldin Talks to Tom Holert." *Artforum International* 41 (March 2003): 232–33.

Iles, Chrissie. *Into the Light: The Projected Image in American Art, 1964–1977.* Exhibition catalogue. New York: Whitney Museum of American Art and Harry N. Abrams, 2001.

*Images, Images, Images: The Book of Programmed Multi-Image Production.* Rochester, N.Y.: Eastman Kodak, 1979.

Jenkins, Janet, and Kathleen McLean, eds. *Peter Fischli and David Weiss: In a Restless World.* Exhibition catalogue. Minneapolis: Walker Art Center, 1996.

Johnson, Ken. "Jonathan Monk: Free Lane." *The New York Times,* 18 January 2002.

*Jonathan Monk.* Exhibition catalogue. Glasgow: Tramway; Nantes, France: Frac des pays de la Loire, 1996.

Judd, Donald. *Complete Writings, 1975–1986.* Eindhoven: Van Abbemuseum, 1987.

Kaprow, Allan. *The Blurring of Art and Life.* Edited by Jeff Kelly. Berkeley and Los Angeles: University of California Press, 1996.

Katz, Vincent, ed. *Black Mountain College: Experiment in Art.* Cambridge, Mass.: MIT Press, 2003.

Keller, Christopher, ed. *Sur.faces: Interviews, 2001–2002.* Frankfurt am Main: Archiv für aktuellen Kunst, 2002.

Krauss, Rosalind. "First Lines: Introduction to *Photograph.*" In *James Coleman,* 9–25. Exhibition catalogue. Barcelona: Fundació Antoni Tàpies, 1999.

————. "Louise Lawler: Souvenir Memories." *Aperture* (Fall 1996): 36–39.

————. *A Voyage on the North Sea: Art in the Age of the Post-Medium Condition.* New York: Thames and Hudson, 2000.

Kroksnes, Andrea. "Louise Lawler: Specters of Modernism." *Parkett* 57 (1999): 156–61.

Kuspit, Donald. "The Art of Exhibition: The Only Art Worth Exhibiting?" *The New Art Examiner* (November 1993): 14–17.

Leffingwell, Edward. *Flaming Creatures: Jack Smith, His Amazing Life and Times.* Exhibition catalogue. London: Serpent's Tail; New York: The Institute of Contemporary Art/P.S. 1 Museum, 1997.

Linehan, Joel. "Willie Doherty: The Press Invented a Fable. . . ." *Third Text* 48 (Autumn 1999): 108–11.

Lippard, Lucy, ed. *Six Years: The Dematerialization of the Art Object from 1966 to 1972.* Berkeley and Los Angeles: University of California Press, 1997.

Lucie-Smith, Edward. *Art in the Seventies.* Ithaca, N.Y.: Cornell University Press; New York: Phaidon Press, 1980.

Mayne, Jonathan. "Thomas Gainsborough's Exhibition Box." *Victoria and Albert Museum Bulletin* 1, no. 3 (1965): 17–24.

Meyer, Richard. "The Jesse Helms Theory of Art." *October* 104 (Spring 2003): 131–48.

Molesworth, Helen. *Work Ethic.* Exhibition catalogue. Baltimore: The Baltimore Museum of Art; University Park: The Pennsylvania State University Press, 2003.

Morgan, Robert. "Tales from the Dark Side." *Afterimage* (Summer 1987): 25–26.

Moure, Gloria. *Ana Mendieta.* Exhibition catalogue. Santiago de Compostela, Spain: Centro Galego de Arte Contemporánea, 1996.

*New Adventures in Indoor Color Slides.* Rochester, N.Y.: Eastman Kodak, 1967.

Newhall, Beaumont. *The History of Photography: From 1839 to the Present Day.* New York: The Museum of Modern Art, 1988.

Parent, Alain. *Dennis Oppenheim.* Exhibition catalogue. Montreal: Musée d'art contemporain, 1978.

Phillips, Sandra A., and Maria Morris Hambourg. *Helen Levitt.* Exhibition catalogue. New York: The Metropolitan Museum of Art; San Francisco: San Francisco Museum of Modern Art, 1991.

*Planning and Producing Slide Programs: Business, Education, Government, Industry, Medicine, Tourism.* Rochester, N.Y.: Eastman Kodak, 1975.

Popper, Frank. "The Luminous Trend in Kinetic Art." *Studio International* 173 (February 1967): 72–76.

"The Projected Image in Contemporary Art." A roundtable discussion with George Baker, Matthew Buckingham, Hal Foster, Chrissie Iles, Anthony McCall, and Malcolm Turvey, edited by George Baker. *October* 104 (Spring 2003): 71–96.

Reynolds, Ann Morris. *Robert Smithson: Learning from New Jersey and Elsewhere.* Cambridge, Mass.: MIT Press, 2003.

Rickey, George. "Origins of Kinetic Art." *Studio International* 173 (February 1967): 65–69.

Rorimer, Anne. "Lothar Baumgarten: The Seen and the Unseen." In *Site-Specificity: The Ethnographic Turn,* edited by Alex Coles, 30–48. London: Black Dog Press, 2000.

Rosenblum, Naomi. *A World History of Photography.* New York: Abbeville Press, 1984.

Schimmel, Paul. *American Narrative/Story Art: 1967–1977.* Exhibition catalogue. Houston: Contemporary Arts Center, 1977.

Schulze, Sigrid. "Lichbild und Schule: Zur Verwendung der Diaprojektion im Schulunterricht in den zwanziger Jahren." In *Dia/Slide/Transparency,* 166–72. Exhibition catalogue. Berlin: Neuen Gesellschaft für Bildende Kunst, 2000.

Scott, Clive. *The Spoken Image: Photography and Language.* New York: Reaktion Books, 1999.

Seifermann, Ellen, and Beat Wismer. *Robert Barry: Some Places to Which We Can Come: Works, 1963–1975.* Exhibition catalogue. Nürnberg: Kunsthalle Nürnberg, Aargauer Kunsthaus, and Kerber Verlag, 2003.

Smithson, Robert. "A Sedimentation of the Mind: Earth Projects." In *Art in Theory, 1900–2000: An Anthology of Changing Ideas,* edited by Charles Harrison and Paul Wood, 863–68. Oxford: Blackwell, 2003.

Sobieszek, Robert. *Robert Smithson: Photo Works.* Exhibition catalogue. Los Angeles: Los Angeles County Museum of Art; Albuquerque: University of New Mexico Press, 1993.

Sontag, Susan. *Against Interpretation.* New York: Anchor Books, 1990.

———. "Regarding the Torture of Others." *The New York Times Magazine,* 23 May 2004.

Stafford, Barbara Maria, and Frances Terpak. *Devices of Wonder: From the World in a Box to Images on a Screen.* Los Angeles: Getty Research Institute, 2001.

Stella, Frank. *Working Space: The Charles Eliot Norton Lectures, 1983–84.* Cambridge, Mass.: Harvard University Press, 1986.

Stieglitz, Alfred. "Some Remarks on Lantern Slides." *Camera Notes* (October 1897). [Reprinted as *Some Remarks on Luntern Slides.* New York: DaCapo Press, 1978.]

Tsai, Eugenie. "Interview with Dan Graham by Eugenie Tsai, New York City, October 27, 1988." In *Robert Smithson: Drawings from the Estate,* 8–23. Münster: Westfälisches Landesmuseum für Kunst und Kulturgeschichte, 1989.

Watkins, Jonathan. *Ceal Floyer.* Birmingham, U.K.: IKON Gallery, 2001.

Wilhelm, Henry. *The Permanence and Care of Color Photographs: Traditional and Digital Color Prints, Color Negatives, Slides, and Motion Pictures.* Grinnell, Iowa: Preservation Publishing, 1993.

Wollen, Peter. "The Two Avant-Gardes." *Studio International* 190, no. 978 (1975): 171–75.

# index

# photo credits

Advertisement for magic lantern show, courtesy the Photographic History Collection, National Museum of American History, Smithsonian Institution, negative number 95-3576, p. 8; Giovanni Anselmo, courtesy the artist and Marian Goodman Gallery, New York, photo by Michael Goodman, p. 57; Argus B Model and Nikomat slide projectors, courtesy George Eastman House, pp. 70 and 71; Art & Language, courtesy the artists, private collection, France, p. 34; Robert Barry, courtesy the artist and Klemens Gasser & Tanja Grunert, Inc., New York, photos by Mitro Hood, pp. 74 and 77; Lothar Baumgarten, courtesy the artist and Marian Goodman Gallery, New York, pp. 60, 78, and 81; biunial lantern slide projector, Kodak Supermatic 500 slide projector, Instamatic camera, Leitz Wetzlar slide projector, standard magic lantern slide projector, and transformation projector for lantern slides, courtesy Albin O. Kuhn Library and Gallery, University of Maryland, Baltimore County, pp. 70 and 71; Marcel Broodthaers, courtesy the Estate of Marcel Broodthaers and Marian Goodman Gallery, New York, photos by Mitro Hood, pp. 20, 82, and 85; James Coleman, courtesy the artist and Marian Goodman Gallery, New York, pp. 59, 86, and 89; Jan Dibbets, courtesy the artist and Barbara Gladstone Gallery, New York, pp. ii, viii, and photo by Mitro Hood, pp. 90, 92, and 93; Willie Doherty, © the artist and Alexander & Bonin, New York, p. 97, photo by Mitro Hood, p. 94; Eastman Kodak Company, courtesy © Eastman Kodak Company 2004, pp. 2 and 150; Peter Fischli and David Weiss, courtesy the artists and Matthew Marks Gallery, New York, pp. ii, 61, 98, and 101 and courtesy Creative Time, New York, p. 31; Dan Flavin, © 2004 Estate of Dan Flavin/Artists Rights Society (ARS), New York, Collection Dia Art Foundation, New York, photo by Cathy Carver, © Dia Art Foundation, p. 17; Ceal Floyer, courtesy the artist and Lisson Gallery, London, photo by Dave Morgan, p. 102; Rainer Ganahl, courtesy the artist, New York, www.ganahl.info, p. 50; Nan Goldin, courtesy the artist and Matthew Marks Gallery, New York, pp. 26, 106, and 109; Dan Graham, courtesy the artist and